Oil Painting

Step By Step

Oil Painting

Step By Step

Ted Smuskiewicz

NORTH LIGHT BOOKS

Cincinnati, Ohio

About the Author

Ted Smuskiewicz was born in Chicago, Illinois, in 1932. He received his formal art education under William Mosby and Joseph Vanden Broucke at the American Academy of Art in Chicago, and has himself been a member of the faculty there—teaching oil painting and pastel painting—since 1979.

Mr. Smuskiewicz exhibits his work regularly throughout the country in galleries and national exhibits. His paintings hang in many private and corporate collections, both in the United States and abroad. His first book on painting, *Creative Painting of Everyday Subjects*, was published in 1986. He has written for *American Artist* magazine and his work has been featured in different publications including *Southwest Art* magazine, *Art West* magazine and *Midwest Art*.

Oil Painting Step by Step. Copyright © 1992 by Ted Smuskiewicz. Printed and bound in Hong Kong. All rights reserved. No part of this book may be reproduced in any form or by any electronic or mechanical means including information storage and retrieval systems without permission in writing from the publisher, except by a reviewer, who may quote brief passages in a review. Published by North Light Books, an imprint of F&W Publications, Inc., 1507 Dana Avenue, Cincinnati, Ohio 45207. First edition.

96 95 94 93 92 5 4 3 2 1

Library of Congress Cataloging in Publication Data

Smuskiewicz, Ted
 Oil painting step by step / Ted Smuskiewicz.—1st ed.
 p. cm.
 Includes index.
 ISBN 0-89134-426-8
 1. Painting—Technique. I. Title.
ND1500.S587 1992
751.45—dc20 92-8862
 CIP

Edited by Greg Albert and Rachel Wolf
Designed by Paul Neff

Dedication

To my father, Joseph, who years ago introduced me to the enchanting world of color and painting.

Acknowledgments

I thank Naldo Coelho of Chicago for his excellent work in photographing my paintings for this book.

I also would like to thank Greg Albert, senior editor of North Light Books, for his advice and help in getting this book started.

A special thanks to my wife, Dorothy, herself an oil painter, who gave me support and encouragement while I worked on this book.

And finally, I acknowledge and extend my appreciation to all the artists from before, known and unknown, who through the centuries have contributed to the development of oil painting.

Table of Contents

A Good Beginning

Lay the groundwork for great painting with this clear and simple explanation of the basics.

Oil Colors • Brushes • Painting Knives • Supports and Grounds • Canvas Preparation • Panel Preparation • Painting Mediums • Drawing and Seeing • Measuring and Comparing • Basic Brush Use
Project A Good Beginning

Light and Value

Add beauty and excitement to your painting by using light to the best advantage.

How Light Reveals Form • Three Divisions of Value • Form Building With Value and Edges • Tonal Value Arrangement • The Enclosing Picture Rectangle • Dark and Light Distribution • Balance
Project Light and Value

Using Color

See how to express your feelings about a subject with color and great-looking color techniques.

Light and Its Effect on Color • Understanding Basic Color Principles • Influence of Surroundings • Light Temperature and Its Effect on Form • Color Temperature and Form • Color Balance • Color Harmony • Learning to See and Mix Good Color • Finding and Mixing Shadow Colors • Painting With a Limited Palette • Color Techniques • Brush and Knife Color Effects • Demonstration: Color Block-In • Glazing With Color
Project Using Color

Painting Techniques

Lots of close-up illustrations will build your confidence in and understanding of this wonderful painting medium.

Using a Brush and Knife • Step-by-Step Demonstration
Project Painting Techniques

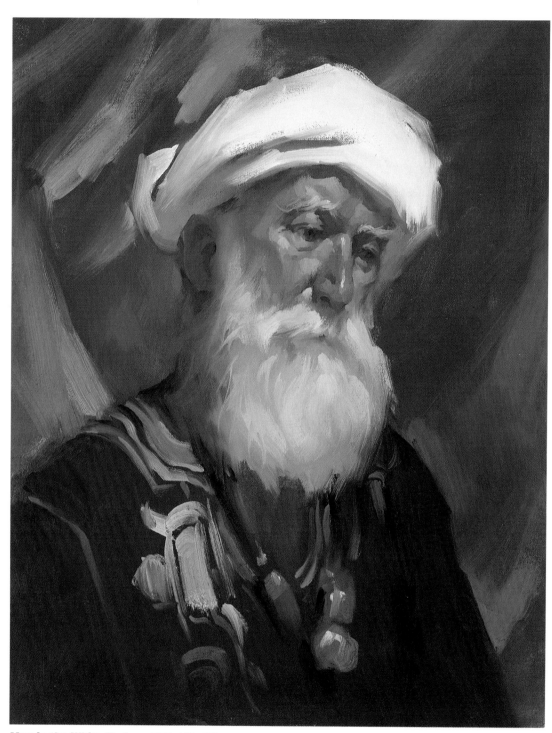

Man in the White Turban, 1991, 16″ × 20″

Introduction

Since their first development and use centuries ago, oil colors or paints have been quickly adopted by artists the world over. The reason for their popularity can be found in their permanence throughout the years if correctly used and also in the many different ways it is possible to work with oils. Individual painters have achieved many impressive pictorial effects using the natural working qualities of this delightful painting medium.

Of all the different ways of putting paint on a surface, working with oil colors gives an artist some of the most expressive yet controlled approaches to painting. Oil painting can produce a wide range of light and color effects. Delicate brushstrokes and subtle transparent washes can be easily changed to create bold and powerful effects almost instantaneously with the same brush. It is simultaneously capable of heavily textured surfaces as well as softer brushed out effects.

Although oil painting gives an artist many different and expressive approaches, it still is one of the most forgiving mediums. The slower drying time of oil colors allows a painter to correct errors easily or even to change the idea of a painting after it has been started without losing the freshness of approach. Its opaque qualities give the artist the option to overpaint or completely cover a painting with new and different colors.

Artists have painted every conceivable subject in this versatile medium. Any subject, whether from life, nature or altogether imaginary, can be effectively rendered with oil colors. Small wonder then that oil painting has been so widely used by artists since its early beginnings years ago.

This book is about learning to paint with oil colors step by step. Since learning to paint first involves acquiring basic skills in good painting procedure, I have arranged this book toward that goal. My book is structured to teach you in a progressive manner from the simplest beginning techniques for using oils to their advanced use in more difficult subjects. Through use of these basics and continuous practice with them on more difficult problems, you will begin to learn.

Each chapter is devoted to an important theme that will be covered thoroughly but in an easy to follow manner. In my experience as an artist and teacher, I have found that demonstrations that clearly illustrate the idea being studied are a very effective way of teaching. Therefore, I have introduced this approach in my book as an important part of its structure.

A chapter project that is informative as well as enjoyable will guide you into immediately using what has been covered, giving you valuable learning experience. The project will also prepare you for the next chapter by giving you the basics necessary to get the most out of it. Throughout this book, you can proceed at your own pace, devoting as much time as you feel is necessary to completely learn each idea before advancing to the next one.

Learning to paint involves many different elements that can be somewhat confusing at times. However, by taking them on separately at first to more fully understand their individual use, you will find them easier to grasp. Through this approach you will begin to use this book to improve and develop your skills in oil painting.

Chapter One

A Good Beginning

Although a good painting can begin in several ways, it is the understanding and skillful use of painting material that first gives control and confidence to a painter. Many different materials and kinds of equipment are used by painters to achieve their individual approach and technique; however, certain basics are always necessary for successful painting, no matter how one works. In developing and painting the picture shown below, I used sound ideas of color and composition as well as material use. In this chapter, we will concentrate on achieving a good beginning by learning what an oil painter uses to paint with and how that material is used. The basic technique of seeing and drawing as used by a painter will also be covered, as this too is an important first step in painting. More detailed and in-depth use of painting material and approaches for specific subjects such as landscapes and portraits are covered in following chapters.

Remember, it is only through developing sound skills in material use and drawing procedure that a good beginning is made possible. What is not begun correctly cannot be successfully finished.

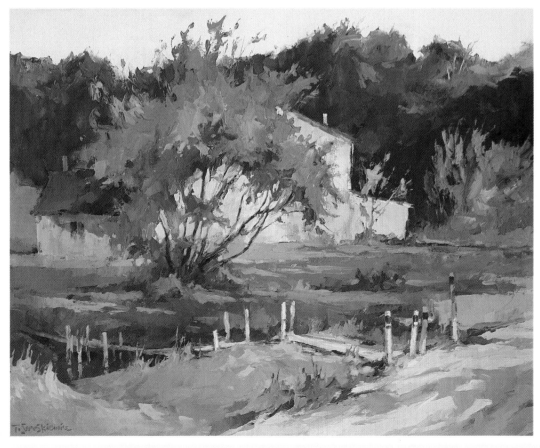

An Autumn Afternoon, 1990, 14″ × 18″

Oil Colors

Oil color is made by grinding and mixing together dry color pigments with linseed oil. The linseed oil acts as a binder that holds the pigment particles together upon drying. Linseed oil dries by absorbing oxygen from the air (oxidation) and then solidifying into a tough and durable film that cannot be liquefied again with normal paint thinners. Since linseed oil dries slowly, painting with oil colors gives the artist a flexible painting material that can be easily corrected or changed without losing a freshness of approach.

Some color pigments are made from materials found in a natural state and have been used since ancient times. The natural earth colors of yellow ochre, raw sienna and the earth reds are used as found in nature with little treatment besides washing and filtering out foreign matter. They are the most permanent oil colors. When a natural earth color such as raw sienna is heated in an oven, its appearance changes from a lighter yellow-brown to a darker red-brown burnt sienna.

Other pigments are man-made of different combinations of natural and synthetic minerals. They are permanent and usable in all oil painting techniques. Some examples of these color pigments are the cadmium yellow and reds, cobalt blue, ultramarine blue, cerulean blue and viridian.

Organic color pigments are the least permanent and have been mostly replaced by man-made pigments. For instance, alizarin crimson has replaced the beautiful but unstable madder lake, which comes from the madder root.

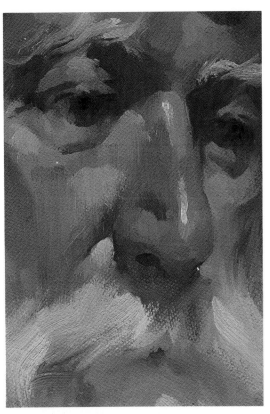

Oil paint allows great diversity in brushwork. This detail shows how it is possible to combine deliberate brushstrokes and soft blending together to bring out form in an oil painting.

Color Pigments and the Primary Colors

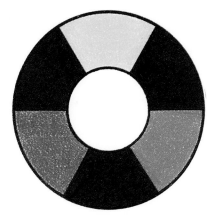

Primary Color Circle

Yellow Family	Red Family	Blue Family
Cadmium Yellow Pale	Cadmium Red Light	Viridian Green
Cadmium Yellow Light	Terra Rosa or	Cobalt Blue
Yellow Ochre	Venetian Red	Cerulean Blue
Raw Sienna	Alizarin Crimson	Ultramarine Blue Deep
	Burnt Sienna	Ivory Black

Organizing your color pigments into family groups of the primary colors *yellow*, *red* and *blue* will help you control their use in color mixing. Understanding the relationship of one color to another on the primary color circle helps you select and use the correct color pigment. For instance, if a color pigment in the yellow family is mixed with a color pigment in the blue family, a green color will always be the result. Laying out your color pigments on the palette in separate sections of primary color family groups gives you greater control in color mixing. This idea will be covered more fully later.

Brushes

Of all the different ways to put paint on canvas when painting, using a brush is probably the most popular and easiest approach. Holding a brush and painting with it is a natural way of using oil paint.

The basic type of brush used in oil painting is a bristle brush. The natural firmness and springiness of bristle hair make it ideal for working the heavier consistency of oil paint. A good brush is long wearing and has a delicate touch or spring. It is made of natural curving and interlocking hog bristles, tied and set in a metal ferule that is fastened to a long hardwood handle. The long handle extends the artist's reach when painting and also serves as a convenient measuring aid as will be seen later. When buying brushes, check the bristles for their shape and working quality. The bristles of a good brush should spring back to their original shape after use. Also check the alignment of handle to metal ferule and be sure that the ferule is not loose.

Bristle brushes are numbered according to size, with no. 1 the smallest. As the brush size increases, the numbering goes up. There are four basic types of brushes, each with its own particular working qualities: the *flat, filbert, bright* and *round*. A basic assortment of bristle brushes would include the no. 2, 6 and 10 flats. Adding the filbert, bright and round to your supply would increase the painting effects of your brushwork.

Another type of brush used in oil painting is the nylon filament or synthetic hair brush. These brushes generally lack the firmness and springiness of bristle brushes, but if used correctly, they will give satisfactory results. When used with a painting medium that thins out the heavier consistency of oil paint, a well-made synthetic hair brush will give good results in brushwork.

A soft hair brush made of natural or synthetic hair is also used in oil painting. The best natural soft hair brushes are made from red sable. Some soft hair brushes are made from a combination of both natural and synthetic hairs. Soft hair brushes are generally smaller and are used for controlled detail work. However, some painters use soft hair brushes in larger sizes as their technique and approach to painting require them. In glazing, for example, a softer handling brush is more adaptable to applying the thin oil washes of color. Soft hair brushes for oil painting have long handles and are available in flat, filbert, bright and round brush styles.

All brushes used for oil painting should be well cleaned after painting by rinsing them out in paint thinner and washing well with soap and water. Dry the cleaned and rinsed out brushes, reshape, and allow them to dry thoroughly. While they are drying, be careful not to let anything touch or distort their shape.

Flat A flat is an all-purpose brush with square corners that can hold a lot of paint and give a wide range of brush effects. It is flexible and springy because of its longer bristles.

Bright A bright is a specialized brush with square corners that gives you more handling control because of its shorter bristles. It lends a crispness and hard edge to brushstrokes. This brush is a favorite with many landscape painters.

Filbert A filbert has longer bristles with rounded corners that deliver brushstrokes with softer edges. It is a good brush for portrait or figure work where softer edges and subtle blending are important. It can hold a large quantity of paint for full brushstrokes.

Round A round is a more specialized brush that is constructed without any flatness. Its tip comes to somewhat of a point giving it linear or naturally narrow brushstrokes. When more pressure is applied, wider brushstrokes can also be made.

Painting Knives

Another effective way of applying oil paint is with a painting knife. It is used primarily for painting but also works well in mixing color. Painting knives are made of flexible tempered steel and are available in a variety of different shapes and sizes, each capable of creating different effects. Triangular-shaped blades that are neither too large or small nor too pointed seem to be easier to control and more versatile. The trowel-like design is best for oil painting because it provides for clearance between fingers and the wet surface of the painting. A palette knife, like a painting knife, can be used both to mix and apply paint. However, a palette knife's main use is in mixing color; therefore, it is larger and stiffer than a painting knife. Knives naturally result in a sharp-edged and crisp look with a rapid build-up of paint. Colors reflect back to the viewer more brilliantly than brushwork because of the knife's smoother surface effect. Oil paint can be applied simultaneously in a heavy or thin way. The basic way of applying paint with a knife is with a spreading or scraping action.

Trowel-Shaped Painting Knife

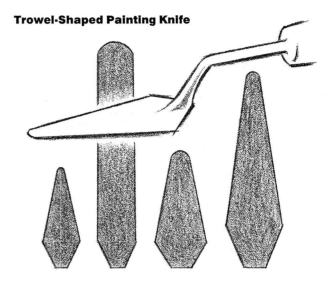

Scraping Holding the leading edge of a knife downward and touching the surface like a snow plow, you can scrape and lift oil paint off the surface. Scraping off excess paint and repainting back into the scraped area with a brush is a good way to develop a painting without losing all the color while still avoiding heavy paint buildup.

Spreading When the leading edge of a knife is lifted in the direction of a stroke, oil paint is spread out over the surface. If the underside of the knife is well loaded with paint, a thick application of paint will result. However, you shouldn't add thick layers of paint as if you were plastering a wall. Spread the paint out and let it build up gradually. Whether a knife is used for mixing or painting, control should not be relinquished for chance effect.

Painting Spreading and scraping allow you to simultaneously apply the naturally thick oil paint in a heavily textured way and in flat, thinned-out passages. Painting with a knife uses these two basic actions to achieve a variety of expressive effects.

Supports and Grounds

The oil painter has a variety of different surfaces to work on. Each can affect the appearance of the finished painting in a different way because of its individual working qualities. Material and surfaces to work on are as varied as the artists themselves. Something could be made or found to suit any individual aesthetic requirement. Some of the many different surfaces to paint on are the traditional canvas, cloth or fabrics, panels of many kinds, wood and other fibrous material including paper. These different materials are called supports.

For oil paint to be used on some kind of support, the surface must first be covered with a ground. A ground seals the surface so oil is not excessively absorbed by it. The ground also makes it easier for paint to adhere or stick. For permanence in oil painting, all supports or surfaces should be covered with a ground.

The most commonly used grounds are oil base paints such as white lead, a gesso made of chalk with a glue binder, and the popular acrylic gesso. Both oil base paints and acrylic gesso can be used as a ground on canvas, which is flexible and has some give. The glue and chalk-type gesso should only be used on a rigid nonflexible support to prevent cracking. Acrylic gesso provides a fast and easy way to apply grounds. It will adhere without difficulty to any surface that is dirt and oil free. Acrylic gesso will not adhere well to an oily surface and should never be used to cover oil paintings that are to be painted over.

Linen and cotton are the two basic kinds of canvas used for oil painting. Each has special qualities. The most noteworthy difference between them is the superior strength and durability of linen. However, a well-made cotton canvas of substantial weight can still give a painter a durable and permanent surface at a lower cost. Canvas may even be purchased with a ground already applied to it. The canvas, primed and ready to use, has only to be cut to size and mounted on stretcher bars. Primed canvas is usually purchased in six-yard rolls. A variety of styles is available, from very smooth to rough surfaced. Each different surface lends a special effect to the appearance of a painting, thereby helping an artist to paint creatively.

Although commercially prepared canvas panels provide a quick and convenient surface to paint on, they are a less permanent and durable alternative to regular linen or cotton canvases and are limited in surface and working qualities. They should be used for studies only and not where permanence is required.

Smooth Canvas Softer edges and subtle color blending are characteristic of smooth canvas. This surface is a favorite with many portrait painters.

Rough Canvas More diversity and contrast in brushwork is possible with a rough canvas. This surface is suited for landscape or bold and expressive painting techniques.

Textured Surface Where detail is not important, this surface allows much bold expression. For permanence, textured surfaces should be built up on rigid supports such as panels.

Canvas Preparation

To make best use of the qualities of canvas, mount or stretch it on stretcher bars. The slight give to the surface of a stretched canvas allows a more sensitive and responsive brushstroke that gives important subtle control to the artist.

Stretcher bars are cut on the end with a tongue and groove design that allows movement with stability. The assembled bars or overall picture size may be expanded slightly by gently driving wedges or keys between the bars in their inside corner slots. This design also makes it easier to remove slack that may develop in the stretched canvas.

After the stretcher bar frame is assembled and all four corners are flush and even, check its squareness with a carpenter's square. You can also square the frame by making both diagonal measurements equal. Drive staples across the corner joints on the back side of the frame to help keep it square. Now carefully lay the canvas, which has been cut about two inches larger on each side, face or primed side down on a flat surface. Place the stretcher bar frame on top. Fold the canvas over on one side and staple it at the midpoint of that frame side using a staple gun. With canvas-stretching pliers, carefully pull the canvas over the opposite side with an even but firm pressure until it is somewhat taut. Staple the canvas to that side of the frame, then stretch and staple the canvas in the other direction on the remaining two sides. As you stretch the canvas across the sides of the frame, always pull and staple from the center outward to the corners to avoid unnecessary wrinkles. When using canvas pliers, the curved bottom jaw should rest on the side of the stretcher bar and roll outward to pull the canvas tight. When you reach the corners, fold the canvas over just as you would a bed sheet and staple it. Do not cut off the extra canvas that extends over the frame; fold it over the back and staple it. This will make it easier to remove and remount the canvas if necessary later.

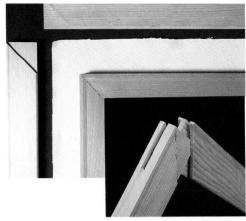

Stretcher bars fit together with a tongue and groove design. Allow two extra inches of canvas on all four sides for gripping with the canvas stretching pliers.

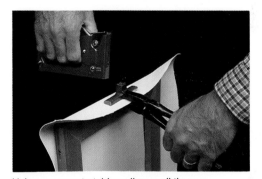

Using canvas stretching pliers, pull the canvas with an even but firm pressure. The curved bottom jaw of the pliers should rest on the stretcher bar and roll outward, pulling the canvas tight. Always pull and staple the canvas from the center out to avoid wrinkles.

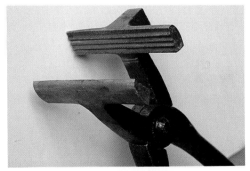

Canvas stretching pliers give a firm grip with deeply grooved jaws. The curved bottom jaw rolls upward on the side of the stretcher bar pulling the canvas tight. The top jaw has a handy projecting square hammer.

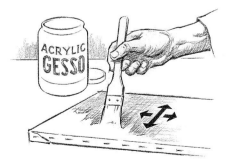

Applying Gesso Ground Apply gesso with a wide brush, brushing in both directions. Two light coats are better than one heavy application. It will dry in two hours.

Panel Preparation

Painting panels give the artist a convenient and versatile surface to work on, not only for studies and sketches but also for finished paintings. The best and most permanent panels are those that you make yourself.

An all-purpose panel can be made out of hard composition board used in building and widely available under the brand name Masonite. It is made of wood fibers that are heated and compressed into a sturdy, rigid panel. It is a strong surface that will not crack easily. It can be purchased in standard 4 × 8-foot panels or in 2 × 4-foot panels and in thicknesses of ⅛- and ¼-inch. Use the *untempered* type as it contains no oil additives and is able to hold an acrylic gesso ground more permanently. To prevent warping, use the ¼-inch thickness for larger panels and the ⅛-inch size for smaller panels.

After the panel is cut to size with a handsaw, lightly sand the smooth side with fine sandpaper so the gesso will adhere to it. Clean off all dust and dirt with a rag dampened in water. Lay the panel on a flat surface and apply acrylic gesso using a 1½-inch wide brush. Be sure to stroke in both directions and also apply gesso to the edges. After the first coat of gesso has dried, lightly sand the surface with fine sandpaper and apply a second coat. The panel will be ready to paint on as soon as it dries.

For textured effects you can mount raw canvas, different textiles, and even textured paper on a panel before applying acrylic gesso. Use a good water-soluble glue product made for fibrous materials and brush it over the panel and on one side of the raw material to be mounted. Be sure to use enough glue for thorough bonding. While the panel's surface is still wet with glue, press and evenly spread the material to be mounted over it. Allow it to dry thoroughly overnight before applying acrylic gesso to the surface.

Heavier and more pronounced textured surfaces can be built up on a rigid panel using a variety of different materials from marble dust to crushed or shredded paper with gesso as a binder.

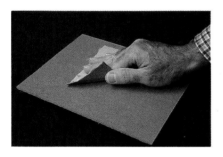

Left After the panel is cut to size, lightly sand the smooth side with fine sandpaper. Clean off any dust and dirt with a water-dampened rag.

Right Using a wide brush, apply gesso to the surface in even strokes in both directions. Gesso the edges as well. Lightly sand the first coat and then apply a second coat.

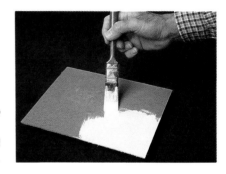

Solvents

When painting in oils, a solvent or paint thinner must be used to thin the paint and to clean equipment. The two main solvents used in oil painting are pure gum spirits of turpentine and mineral spirits. Pure gum spirits of turpentine are obtained by distilling a gum tapped from live pine trees. It is far superior to wood turpentine, which is extracted from ground logs and stumps. Mineral spirits, distilled from petroleum, thin and mix with oil paint in the same way turpentine does and can be used in its place. Some people whose skin is sensitive to turpentine use mineral spirits instead. Mineral spirits do not readily dissolve solid varnish resin, however, and should not be used to make varnish. Mineral spirits are available as a low-odor or completely odorless paint thinner.

Although both turpentine and mineral spirits are relatively safe to use, always follow the directions and heed the warnings on the container label. They are not considered highly volatile and inflammable, but don't use them around an open flame or excessive heat. They should always be used with adequate ventilation, which means having a window open so air will circulate. Solvents or painting mediums can be kept in oil cups attached to the palette for convenience. An oil cup is a metal container that clips onto a palette and is used for holding solvents while painting.

Never use highly inflammable solvents like naphtha, benzene or gasoline. They are extremely dangerous to use for painting, especially when working indoors.

Painting Mediums

Most painters find that starting a painting using oil color as it comes out of the tube is somewhat restrictive, especially on an absorbent surface. Oil paint, because of its thick butterlike consistency, gives good brush effects and surface texture. However, to use the full range of expression including fluid brushstrokes, and also to make the starting of a painting easier, the working consistency of the paint must be thinned using a painting medium. The simplest of all painting mediums is pure gum spirits of turpentine or mineral spirits. Both dilute paint into transparent washes of color that dry rapidly, especially if wiped down. For this reason they are excellent for preliminary drawing with paint and for tonal value underpainting. When using more opaque paint in a heavier way, and in order to keep the thinned-out paint from drying too rapidly, add a little artist-grade linseed oil to the turpentine or mineral spirits. A good ratio for a general-purpose painting medium is one part linseed oil to three parts paint thinner. Instead of linseed oil, you can use stand oil, a more stable oil made by processing linseed oil with heat in the absence of air to prevent oxidation. Stand oil is thicker, slower drying, and less likely to yellow or crack with age. Never use an oil by itself as a painting medium; using excessive oil with oil paints adversely affects their permanence.

Another use of painting mediums is to brighten areas of dried paint before overpainting them. When oil paint dries, some areas may sink in or dry dull because of absorbtion into the ground or paint underneath. In this case, add a little Damar varnish to the painting medium and apply a little of this oil varnish mixture to the sunken or dull surfaces. Wipe off any excess. This will give the dry painting an almost wet surface that will help considerably in softening and losing edges. An oil-varnish medium is also used in glazing, which is covered in more detail in chapter 3.

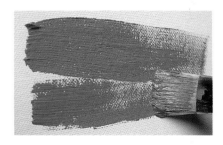

Left Using oil paint without a painting medium produces shorter brushstrokes with broken edges and with a more textured appearance.

Right Using oil paint with a painting medium gives longer and more fluid brushstrokes with almost transparent areas of subtle variations of color.

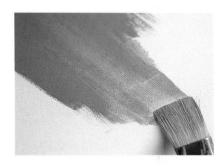

Varnishes

In oil painting, a varnish is used to cover the dried finished painting with a protective coat that also brings out the original luster of oil colors. The most popular and probably best picture varnish for oil paintings is Damar varnish. It is made by dissolving a solid resin obtained from certain Malayan trees in a solvent like turpentine. Damar resins dissolve readily in turpentine but not in mineral spirits.

Damar varnish will dry with a glossy transparent coating that gives excellent protection to a painting. It tends not to darken and yellow with age, and it is easy to remove. If a less glossy or flat finish is desired, use a matte picture varnish. This is a Damar varnish with beeswax dissolved in it to give it a flat finish when dry. Before using, it must be warmed by heating the bottle in hot tap water to completely dissolve the wax. When the varnish is clear, it is ready to use. Try mixing a regular Damar varnish with a matte varnish for a finish with varying degrees of luster.

An oil painting should be thoroughly dry before a final varnish like Damar is applied. Drying could take from several months to a year, depending on how heavily the paint has been applied. To provide temporary protection and also to brighten up dull, sunken-in areas, use a retouch varnish. It can be lightly applied very soon after the painting begins to dry. Use a spray can to avoid accidentally smearing the color with a brush. Retouch varnish is a Damar varnish that has been diluted with more turpentine than regular varnish; it covers a painting thinly. It is especially useful for brightening the sunken-in areas of a painting in progress so color can be accurately matched. A light application of retouch varnish will also make a ground less absorbent and prevent colors from sinking in too much.

Palettes

A necessary and important part of a painter's equipment is a palette. A palette is a flat surface on which oil paint is placed and mixed for use in painting. To function satisfactorily for oil painting, a palette must have a surface that is sealed or primed to avoid absorbing oil from the pigment. Its surface should also be smooth to eliminate unnecessary drag or interference when mixing oil paint.

A satisfactory working palette can be made out of a piece of ¼-inch thick Masonite. It can be obtained in lumberyards or building supply stores. First, cut it to size with a handsaw. A general-purpose table palette can be about 16×20 inches in size. Since a table palette is placed on a table or some kind of stand when it is being used, you can make it almost any size that's convenient for your working area. To seal the palette's surface, apply linseed oil to it and rub it in with your hand. Do not use a rag as it will absorb too much oil before it has a chance to soak into the palette. After several oil applications, you can begin to use your palette. After each use, clean off your palette by scraping off the paint and rubbing in any remainder with a rag

dampened in paint thinner. Then wipe off any excess paint. In this way, the palette's surface will be completely sealed and develop a gray finish. Using this same approach, a palette can be made out of any thin piece of good hardwood such as walnut or cherry. Sometimes old discarded cabinets or other furniture can provide veneered hardwood for palettes.

Another popular type of palette used by oil painters is an arm palette. This is a smaller palette that is rested on the artist's forearm as his hand holds it through a thumbhole near one side. A wiping rag and one or two extra brushes are held in the same hand that supports the palette. Although its mixing area is limited, its small size makes it convenient to carry back a few paces when simultaneously looking at and judging a painting against the subject. This is especially true in outdoor painting and sketching.

Remember, a palette can be a useful tool for a painter if it is used correctly. Its main purpose is for mixing and judging color mixtures. Old dried paint on its surface contributes nothing of value, so keep it clean.

Use the color circle to help you organize your oil colors according to basic families of yellow, red and blue.

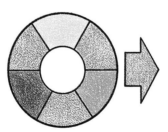

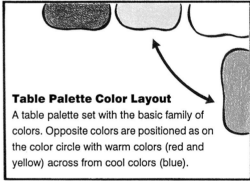

Table Palette Color Layout
A table palette set with the basic family of colors. Opposite colors are positioned as on the color circle with warm colors (red and yellow) across from cool colors (blue).

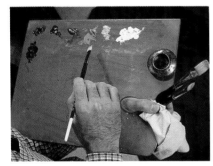

Using an arm palette enables a painter to step back and judge the painting while he mixes colors on the palette. To use an arm palette, insert your thumb into the thumb hole and balance the palette on your forearm. For convenience, an extra brush and wiping rag may be held in the same hand that is holding the palette. An oil cup for holding your paint thinner or painting medium is attached to the palette with a clip.

Using an Arm Palette for Painting

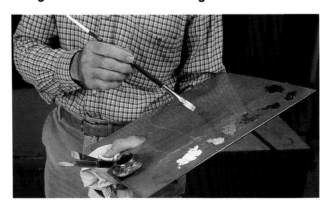

Easels

Another important part of the oil painter's equipment is an easel. An easel holds a painting in an upright position while it is being worked on. Because of the reflective surface of wet oil paint, an upright working position seems to reduce excessive glare and also makes it convenient to see the painting while it is in progress. Easels come in different styles and sizes, each designed to do the basic job of holding a painting when working under different circumstances. For instance, there are indoor studio easels and outdoor sketching easels, table easels and tripod-style floor models that can easily be adjusted for working from standing or sitting positions.

The indoor studio easel is the most rigid and versatile piece of equipment for holding a painting. Studio easels have one or two upright posts and a wide stable base. An adjustable support ledge and clamp hold the painting securely. These easels may be adjusted to tilt forward, eliminating glare from the wet surface of a painting. Indoor studio easels are generally used while the artist is standing. Working this way allows an artist to quickly step back while painting to judge what is being done. The studio easel is typically used with a table palette resting on a small stand in front of it, although some artists prefer to use an arm palette while painting on this easel.

Another type of easel, particularly suited for smaller paintings, is a table easel. The artist works from a sitting position with the easel and painting in front on a table or bench. A table easel's smaller size naturally limits its use to smaller paintings. Some table easels also can be used as convenient wet painting carriers. Since easels are available in a large selection of different styles, be sure to obtain one that will give years of good service.

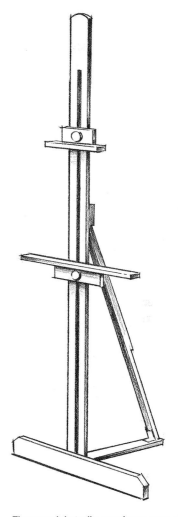

Floor model studio easels are very sturdy and are easily adjustable to different working positions.

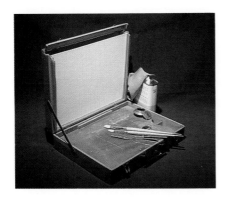

Using a Paint Box as an Easel A wooden paint box, with its enclosed palette and slots in the lid that hold several painting panels, can be used as an all-in-one easel for sketching or painting. Just place the box on your knees while sitting and paint on a panel held in the open lid.

Table easels are used to hold smaller paintings when working from a sitting position at a table.

Drawing and Seeing

A good painting depends on a good drawing for its success. Building your painting on a sound drawing foundation will give you more control in developing your work. Remember, what you put into a painting is what you will eventually get out of it.

Drawing for painting is not only doing preliminary line work that shows where the first colors are placed; it is also the building of form with color itself. An artist is constantly drawing during the painting process. As a painting develops, every value and color added to it develops form and substance by working with or against other values and colors.

In the beginning, the drawing should be rendered so that it suggests a more completed painting. It should show light and dark construction to give a good indication of form. Proportion should be stated by putting in certain important edges and dimensions. The massing or grouping together of values should also be arranged as this is an important part of composition. As color is applied, more control becomes necessary to develop the painting. Subtle adjustments of color and edge refine and bring out individual forms. Thus drawing is always a continuous process in painting, one that begins with the first few lines on an empty canvas and ends with the last brushstroke of color.

Squinting for Simplicity Squinting is the most useful way for a painter to accurately see a subject. When you squint, the amount of light entering your eyes is greatly reduced; form is simplified into basic areas of light and dark. Edges soften and almost disappear. Squinting at a subject will reduce it into the simple masses or groups of value and color that a painting should have as its beginning.

Using a Viewfinder A good drawing begins with first seeing clearly what is to be drawn, with carefully selecting important things to concentrate on and not being sidetracked with minor parts. A viewfinder will help you get your painting started. When you are painting from life, with your subject in front of you, you will see many things at first. A viewfinder or frame will help you concentrate your view on one area. It is also valuable for judging the placement of your subject on the canvas.

A practical but simple viewfinder can be made out of two L-shaped pieces of gray mat board cut about five inches long on each side. Place both pieces together to form a frame. It can be adjusted to the same proportions as your canvas and secured with paper clips.

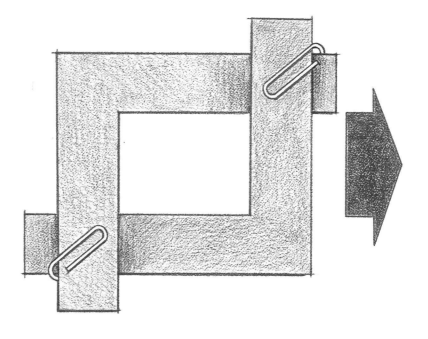

Measuring and Comparing

Comparing one thing or part against another is the basic method for accurately judging and measuring the many different parts of a painting. One part is compared by judging it against another similar part. For instance, a dark value can be compared against another dark value to see which of the two is darker. Colors can be compared against similar colors to accurately judge their differences. If two red colors of the same value are placed next to each other, any difference between them is immediately seen. Placement of different shapes and different edges can also be accurately found by careful comparison of one thing or edge against another.

Measuring is basically comparing, seeing how many units of something compare to or fit into a certain distance, for example, to find out how many lengths of an object will make up the distance between it and something else.

Compare the placement of things or edges by aligning them vertically or horizontally. Using straight lines projected through a subject, note where significant points or edges align with other important places. A narrow, straight brush handle can be used as an aid to aligning different parts together.

When comparing values and colors, squint so that you can barely see your subject. This will reduce the many subtleties of value and color into simpler divisions, making accurate comparisons possible. Remember, squinting is one of the most important techniques used by painters to judge color and value relationships.

You can't see everything at the same time. Your eyes can only see one part at any given moment. Therefore, draw by concentrating on one part at a time, but always compare that part against other things.

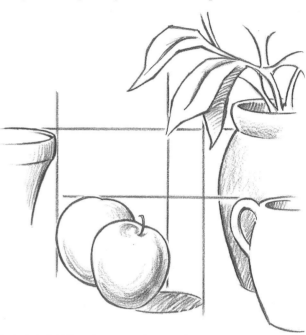

Project straight lines from one edge or point to another in order to see how they relate to each other. The correct placement of something can always be found by comparing it to something else through vertical and horizontal alignments.

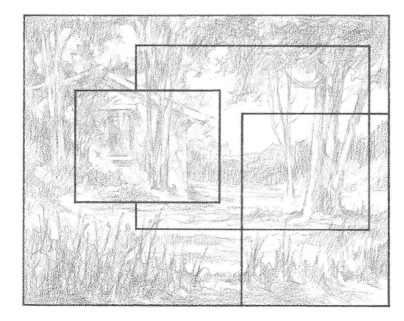

Any one view or subject can have several different possible arrangements for a picture. When you look at a subject through a viewfinder, try to imagine that you are looking at the finished painting. Look past the obvious. A viewfinder will help you see your subject in a different way.

Measuring for Accuracy

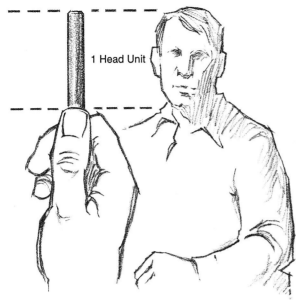

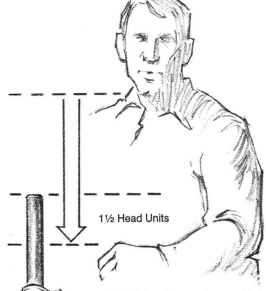

Distances between certain elements in a subject can be accurately measured by using a unit of measure. Here the subject's head is used as a unit. With the top of your pencil lining up with the subject's head, carefully mark the position of the chin with your thumb. Keep your arm fully extended when taking this measurement in order to maintain the same distance between the mark on the pencil and your eye.

To find the distance down to his hand, drop the head unit by slowly lowering your arm and count how many head units are between the subject's chin and his hand. Don't lose your thumb position on the pencil and remember to keep your arm fully extended. This same approach to measuring can be used on other subjects such as still lifes or landscapes.

Comparing

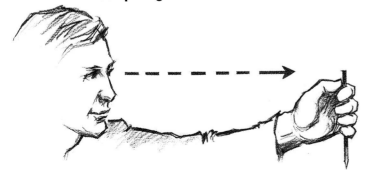

Comparing one unit by marking its size on a straightedge and carefully measuring distances between parts is a sound way to start your drawing or painting. You can also compare things by seeing how different parts align. Use something straight like a pencil or long brush handle to help you.

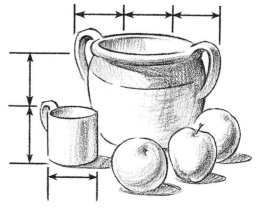

3 Cup Units

1 Cup Unit

Using the cup as a unit of measurement, you can easily find the placement and size of the rest of this still life.

Basic Brush Use

Oil Wash Stroke

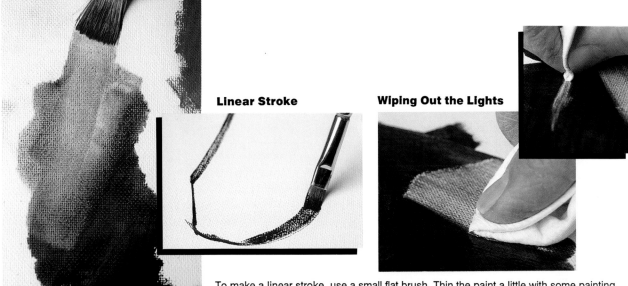

Linear Stroke

Wiping Out the Lights

To make a linear stroke, use a small flat brush. Thin the paint a little with some painting medium to make it flow easily. So the wet paint does not spread excessively, lightly brush the excess paint out on a rag before starting the stroke. By twisting and applying more or less pressure on the brush, you can achieve different thicknesses in the stroke.

You can use a larger brush and thin the paint so it spreads easily to apply a flat or gradated oil wash over a surface. Brushing out the color will lighten it considerably; the painting medium makes the color more transparent and allows the white ground underneath to show through. When an oil color is thinned with a painting medium to make it lighter, a rich and intense lighter color results. If white is used to lighten a color, it becomes opaque and loses its intensity. Lights in darker areas of an oil wash can be wiped out using a rag dampened with paint thinner.

An important working quality of oil paint is its slower drying time. This enables a painter to achieve a wide range of effects with wet-into-wet painting. When painting into a wet surface, wipe off your brush frequently if you want the new color being applied to remain clear. Excessive brushing into a wet surface will cause all colors to mix together. Sometimes this spontaneous color mixing on a painting's surface is what an artist wants.

When you want to create definite edges or a strong contrast of value and color, make only one or two strokes with your brush. Wipe your brush clean and pick up fresh color from the palette for the next stroke. If softer edges or blended and mixed effects are desired, continue brushing in several directions until the overlapping strokes blend together. Remember, using a wiping rag will make your brushwork cleaner and more effective.

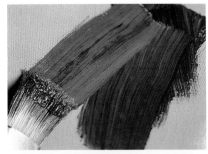

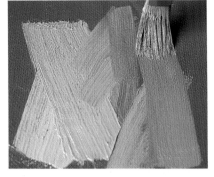

Project A Good Beginning

The following projects will help you to get the most out of this chapter by encouraging you to use its information immediately. For this project, you will work from a simple still life that can be set up on a table. Use a floor or table lamp for a strong light effect. As part of this project, you can make yourself a palette as described on page 10. Prepare or obtain some 12 × 16-inch or 14 × 18-inch painting panels. You will also need bristle brushes, a painting knife, an oil cup to hold paint thinner, and some wiping rags. Titanium white and burnt umber are the only oil colors that you will use, as you will be working with light and dark values.

The first part of the project will be wet-into-wet painting without any preliminary drawing. This will help you become accustomed to using your brush with oil paint. This project is a study, not a finished painting, so detail and finish are not important.

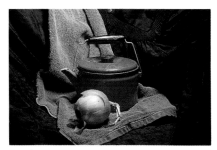

Project: For your still life, select simple items and arrange them with some drapery as a background. Use a strong light source from one direction for strong shadow areas. A still-life box can be made out of a large cardboard box with three of its sides cut away. Your still life is set up inside, the two sides acting as background.

 On your palette, premix two mounds of oil paint in a dark and light value. Use burnt umber and titanium white.

Step 1 Brush the lighter premixed paint freely over the panel's surface. Use a little painting medium to thin the paint, and don't let it build up too heavily on the surface.

Step 2 Brush in the darker values using the darker paint. Be sure to wipe off your brush frequently with a rag. Don't forget to squint.

Step 3 Put in more darks and brush into the painting with some lights to correct the shapes. Blend some areas together for softer edges.

Step 1 Brush the darker paint freely over the panel's surface, covering it thinly.

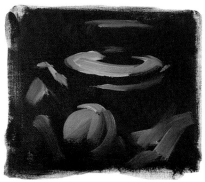

Step 2 Brush in the lighter values as you see them while squinting. Use your wiping rag frequently to keep your brushstrokes clear.

Step 3 Put in more lights and blend some areas together. Brush darks back in to correct edges.

In order to show full form or modeling, it is necessary to have three main divisions of value in your painting. These are the dark, middle and light value ranges. For this part of the project, premix these three values using burnt umber and white. Make sure that you have good divisions between them so they stand well apart from each other. Work from the same still life setup or try changing the light direction for a different lighting effect. Remember to squint as you study your subject so you can accurately judge its value relationships. Compare important edges by aligning them vertically and horizontally against straight lines. Use a narrow brush handle as a guide. This is only a study for practice; don't be concerned if it looks unfinished.

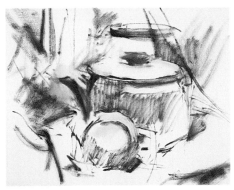

Step 2 Paint in more lines to strengthen form and work in some darker values with an oil wash. Squint while looking to see these main shadow areas.

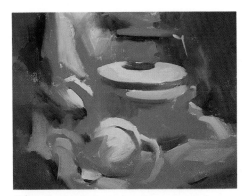

Step 4 Match the main value areas and paint them in. You may have to blend some of the premixed paint for certain areas. Keep your brushes clean by wiping them out frequently.

Project:
Step 1 Start working directly on a panel with a small bristle brush and thinned out burnt umber. Try to put in just the large simple shapes, ignoring all the little details. Compare important edges against each other.

Step 3 Brush in some of the dark- and middle-value paint to begin to build form. Then, using the lighter paint, find some of the important edges.

Step 5 More controlled mixing of values and adding good edges where needed help to develop the form. Remember not to overbrush. Leave your strokes alone.

Chapter Two

Light and Value

In this chapter we will study how light affects the way we see things. When we look at something, we see it a certain way because of the way light illuminates it. Some areas or surfaces receive more light than others. This results in an arrangement of dark and light values. What a viewer sees in a picture depends a lot on how the dark and light values go together or balance within the borders of that picture.

Individual forms or objects in a picture also depend on a value arrangement to show their own shape. By looking at the way dark and light come together on a subject, we can immediately tell what its surface form is doing. For instance, a curved surface shows its value change from light into shadow differently than a flat surface does. It would be difficult to mistake a flat disk for a curved ball even though both of them are circular in shape.

Light does not always affect a subject the same way at all times. This is especially true outdoors because of continually changing light conditions. I painted the picture shown below during midmorning when the sun was lighting the dock from behind. At that time of day, I could see many shadow areas, and they impressed me with their strong pattern or design. As you squint at this picture, notice how all the dark shadow areas hold together regardless of where they are.

The individual forms in this picture identify themselves by being in shadow or showing some light striking part of their surface. It doesn't matter what direction it comes from. The effect of light on value enables us to see things as they really are. Without it there would be nothing; everything would appear flat.

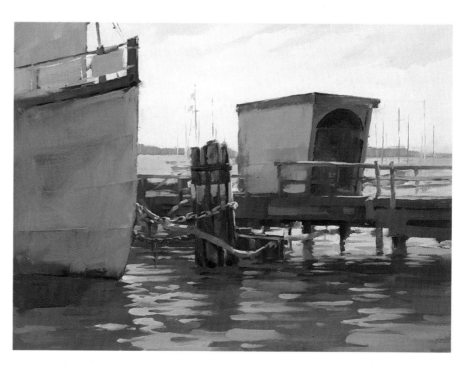

Dock With Pilings, 1984, 12" × 16"

How Light Reveals Form

We live in a world of space and depth. Everything we see in this space has some kind of form revealed by an arrangement of different surfaces. Some subjects, such as the human form, are complex arrangements of many different surfaces. Other things—a box or cylinder, for instance—are much simpler in construction, showing only one or two evenly formed surfaces. Light reveals an object's form by the way it illuminates these surfaces. The more fully exposed to light a surface is, the lighter in value it becomes. As the surface turns from the light, it darkens and eventually recedes into shadow.

For light to clearly show form, it must be coming from a definite direction. With one common light source, all the different surfaces of a subject can express their true relationships to each other, and the subject's form will begin to show.

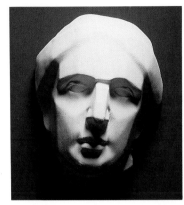

When light comes from one direction, surface forms that receive more light will be lighter in value. As these surfaces turn away from the light, they become darker and eventually recede into shadow. The middle range of values is necessary to show this modeling of form.

The Tonal Value Scale

Dark This value range makes forms more solid by showing their underlying structure.

Middle These values help to hold form together with subtlety of modeling.

Light These values show the direction of light and help control modeling.

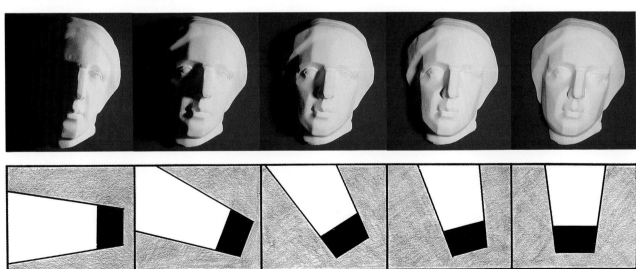

Light must come from one definite direction to show full form. Any other source of light illuminating a subject should be incidental and not as strong. As the light source or direction changes, value arrangements will also change on the subject. The shape of dark and light areas will change in proportion to the changing light direction. Middle values may become more important as they begin to show subtle modeling of surfaces.

Three Divisions of Value

Although just dark and light values can show basic shapes, it is only through the addition of middle values that full form is depicted. On a tonal value scale, the extreme values of black and white are at opposite ends. The transition or change between them makes up the middle range. Thus the middle values identify and show surface form by the way they reveal changes between dark and light areas. Whether a surface form changes gradually or quite suddenly, it depends on a middle value to show what happened.

The middle values also act as a unifying factor by holding together the many complex dark and light areas present in many subjects.

Using middle values in the beginning of a painting makes it easier to hold the painting together. As shown below, the deepest darks and strongest lights can be kept out of a painting until much of the form has been developed using middle-range values.

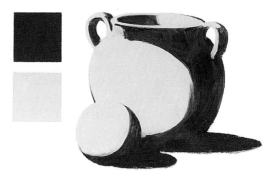

Two values of dark and light are insufficient to depict true surface form and depth.

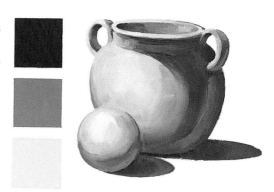

The middle values make it possible to show form and depth.

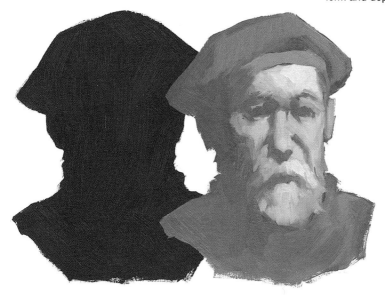

Step 1 When starting a painting, stay with the middle range of values, avoiding the contrast between deep darks and strong lights. You can develop much of the basic form using good edge control. The painting will hold together and corrections can easily be made.

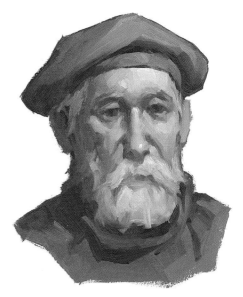

Step 2 Only after all the basic form has been developed with the middle values should the deeper darks and stronger lights be put in. It doesn't take much more value contrast to give an appearance of full form and depth.

Form Building With Value and Edges

Two important elements work together to develop full form in a painting: value and edge control. First, a good dark and light value construction must show a definite light source and its effect. Next, edges must not only act as boundaries between different areas of a picture but must also show divisions or changes in surface form. The way two colors or values come to-

gether tells us about a surface. This information is necessary in order to recognize form. Some edges separate two areas that are so close in color or value that the exact boundary is difficult to see. In this case the edge becomes lost. While the exact edge itself is important, so are the surface color and value just before that edge is reached.

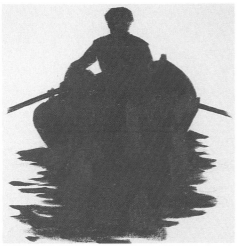

Step 1 A middle value is used to paint the basic shapes of all the individual forms, combining them as one unit. At this stage, the outer edges are important for showing form. Although there is no modeling with other values, we can still recognize the subject as a person in a boat.

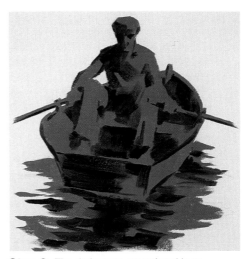

Step 2 The dark areas are painted in to indicate the separate forms that make up this subject. Most edges are similar, and there is very little modeling with any other value. Now we can recognize individual parts of the subject.

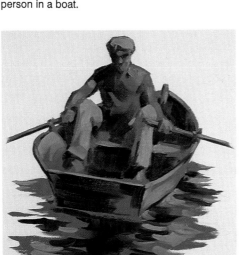

Step 3 As soon as the lighter values are put in, full form begins to emerge. Edges are clarified so that a clearer form and a definite light source is established. The subject now takes on depth and dimension.

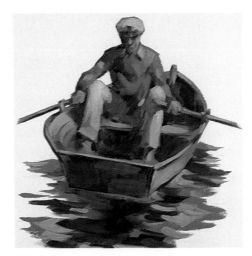

Step 4 More subtlety of values and careful treatment of edges develop the picture to a more complete appearance, demonstrating the full effect of form and light.

Tonal Value Arrangement

Of all the different things that make up a painting, the placement of dark and light values at the beginning is one of the most important. When I paint, I use this first placement or arrangement of values to guide and help me in developing the painting. The tonal value arrangement also helps me to express my feelings about a subject in the way that I put together or balance all these different values. Different ways of seeing a subject require different ways of putting together values.

In order to use this first value arrangement as an effective guide, all the different values that make up a picture must first be reduced into two simple divisions of dark and light. This means that somewhere along the value scale, a division is made, and all the values on each side are combined into two separate groups, one dark and one light. This division usually occurs somewhere in the middle-value range.

Squinting at the subject being painted is a very effective way to visualize this first grouping of values. Remember, when you squint at something, all the different values and colors are reduced into a simple value arrangement. Being able to see and use value in this basic way makes it easier to start a painting.

This painting was first reduced into a simple dark and light value construction. I divided the full range of values into two simple groups of dark and light by combining values.

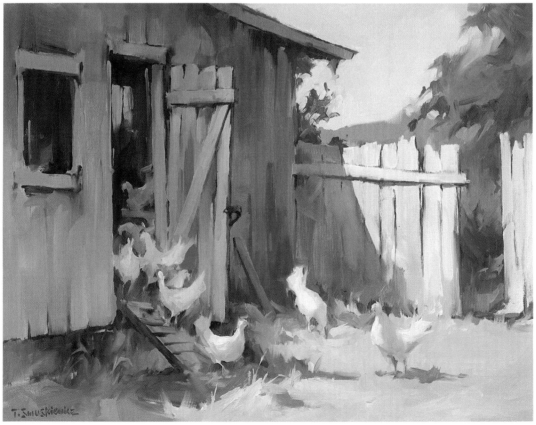

Chicken House, 1990, 12″ × 16″

The Enclosing Picture Rectangle

When something is placed within the borders of a picture, it reacts immediately with the various areas of space created by its placement. Anything that is placed inside this rectangle will be affected both by the enclosing borders and by the other things that are already there, yet the rectangular border is the main element that everything in the picture balances against. Therefore, the first step in arranging or composing a picture is to establish the enclosing borders.

Another important use of picture borders is to limit our view of what we see. When we look at something, it is easy to be overwhelmed. By looking through a viewfinder that acts as the enclosing borders, it becomes easier to concentrate on certain things and balance them against each other.

Painting a successful picture begins with the first placement of different things together within the enclosing borders of the picture rectangle. Good composition requires careful selection and placement of a subject within these borders.

The enclosing picture borders give a limit for something placed within to balance against.

When another element is placed in the picture, it balances against the enclosing borders and against what is already there.

Step 1 The first darks are placed near the lower side of the enclosing rectangle, creating a heaviness at the bottom.

Step 2 Placing darks in the upper-right corner helps to balance the original placement.

Step 3 Simplifying complex value arrangements into basic groups or divisions of dark and light helps you successfully place subjects within the enclosing borders.

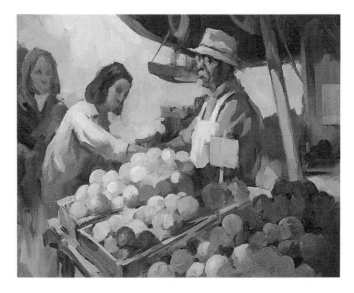

Dark and Light Distribution

In my painting, the first placement of dark and light values is very important to the development of my ideas. In order for this to be done, all the different values that will make up a picture must first be reduced to simple divisions of dark and light. That means dividing all the values into two separate groups. As individual parts of a subject begin to combine with other parts that are similar in value, a massing or grouping together occurs. By *distributing* these dark and light masses throughout the picture area, a visual effect or appearance is created. This first dark and light distribution has a strong influence on the feeling depicted in my painting.

The mood and feeling that I want to show are created by the way I place these dark and light areas against each other. There are two basic placement or distribution patterns. In one, the lighter values seem to connect and hold together. In the other, the darker values connect and flow together. Another important consideration when developing a value distribution pattern is the size of the area that each separate group covers. For a good balance and feeling in a picture, make sure either the dark or light areas occupy more picture space.

The lighter value mass is more connected and covers a larger area than the darks.

Darker values mass together in a connecting pattern and occupy a larger area than the lights.

The different values are first combined into separate groups of darks and lights. This basic distribution pattern has a strong influence on the painting's final appearance. Notice that the darks occupy more of the picture's area and that they are more connected than the lights.

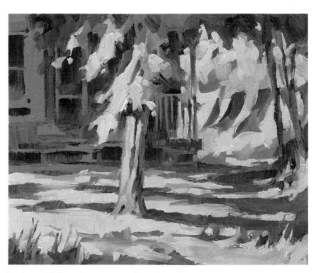

As the middle values are put into the picture, more depth and space is obtained. Attention to the edges and to the modeling of forms with value changes begins to develop more parts in the picture. However, the underlying dark and light distribution is still visible.

Balance

Anything that is put inside the borders of a picture is immediately compared with other things already there. Comparing how different things appear when they are placed together is the basic method of balancing used in painting.

When darker values are introduced into a lighter painting, the added contrast of the darks complements the lighter values, making the picture appear even lighter. If everything is the same value, there can be no balance. Good balance requires contrast. For instance, dark values are balanced against lighter values, harder edges are contrasted with softer edges, and complex tonal arrangements are balanced against simple flat value areas. The balance of opposite or contrasting colors is also an important principle. For good balance, unequal and contrasting elements must be placed together in such a way that they complement rather than cancel each other.

In addition to these general principles, good balance in a painting is also achieved simply through exercising your judgment. Our personal feelings and preferences influence our judgment. After all, they do reflect how we see life. Be honest; always trust your own judgment and feelings about your subject.

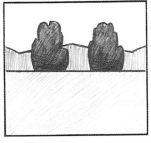 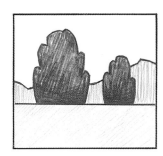

The picture on the left is a static arrangement that lacks interest. By making things unequal in size and placement, a better balance is achieved. A good picture balance always needs contrasting and unequal shapes to complement each other.

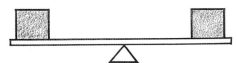

Equal sizes and weights balanced on a lever with the fulcrum in the center give a stable but static appearance.

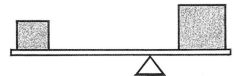

Unequal sizes and weights balanced on a lever with the fulcrum well off-center give a more dynamic appearance.

Using unequal areas of dark and light values is another way to create interesting picture balance. The principles of contrast and unequal divisions and sizes are applied here. In this picture the dark areas are much larger than the lighter areas and are also connected throughout the composition.

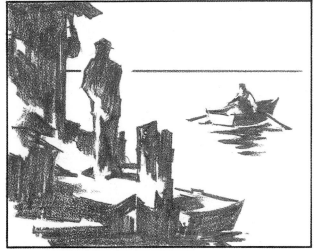

This picture illustrates how interesting balance is created by contrast and unequal divisions. The smaller boat out in the open balances and complements the larger and more solid dock area.

Tonal Areas

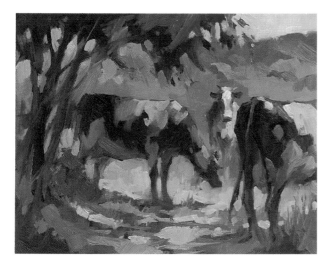

When I start painting, I am very aware of the emotional response and feeling that a subject gives me. Controlling the shape and size of the different values or tones helps me express those feelings through the painting.

Although the darker tones are very influential in this picture, there are enough middle and light areas to give a good balance and show sunlight and shadow. The cows among the trees in a sunny pasture suggest a quiet and peaceful setting, but the strong contrast of dark and light in many places also gives this picture a dynamic effect.

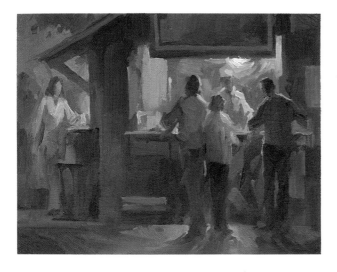

This is a much darker value arrangement. Darker values dominate in the picture, giving it unity but also a certain heaviness. The darkness of night seems to weigh heavily on everything. However, the subject itself and its strong light effect give this picture vitality and interest. Painting a night scene still requires a good balance of different values. To show the dark night effectively, some light must be present to contrast the darkness. No matter what kind of value arrangement is used, there must be enough variation in values to give contrast or balance to the picture.

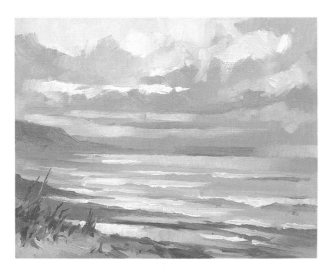

Lighter values predominate in this picture, giving it a restful and calm visual effect. Notice how the values become lighter as they recede into the background. This is a basic principle of achieving depth in a painting. Here, all the values have been shifted toward the lighter side of the value scale to achieve a light and airy effect. The middle values unify this picture by appearing throughout the composition as part of an overall pattern.

Project Light and Value

The first part of this chapter's project is about learning to arrange or compose dark and light masses in a picture. We will start with a simple exercise that will help develop your ability to balance and arrange these masses. For this project, you will use some white drawing paper and two drawing pencils, a hard 2H and a soft 2B. While you are doing this exercise, keep in mind that good balance and arrangement in a picture require the use of unequal divisions and sizes. Repeat this exercise often to develop a good sense of picture balance. Save some of your better results for future use.

Step 1 Draw a picture rectangle five or six inches long on white drawing paper. With a sharp 2H drawing pencil, start at one side and draw lines that wander almost aimlessly until they touch somewhere on another side. Keep drawing lines that go in different directions and continually cross over previously drawn lines. Make sure you fill all the empty spaces and keep your lines lightly drawn.

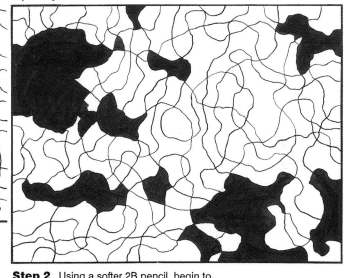

Step 2 Using a softer 2B pencil, begin to fill in some of the spaces that the lines enclose with a solid dark tone. Do this in a random way. Start with several small dark shapes, then connect some of the shapes together to form larger shapes.

Step 3 Begin thinking about balance and enlarge or add other dark shapes by filling in more of the lines, using the principle of dark and light distribution. Keep the dark shapes uneven in size and shape. Connect some shapes together to form larger masses; try to establish connection and movement throughout the picture. For good balance, make sure either the dark or light masses predominate.

Develop this dark and light pattern without thinking of any form or subject. After you have achieved an arrangement of dark and light values that has a good balance and feel, then begin looking for a subject in it.

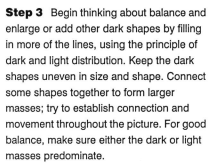

Project Light and Value

Now we will do an exercise using the middle range of values. An arrangement of dark and light shapes can be pulled together by connecting them with a middle or in-between value. In addition to unifying a picture's darks and lights, the middle range of values makes possible full modeling of form. Practice this exercise with pencil on white paper. First, put down some dark shapes separately inside a picture rectangle in a pleasing arrangement. Then introduce a middle range of values to form a connection between them.

For the painting project on the next page, premix three values—a dark, a middle value and a light—using burnt umber and white oil color. Before starting the painting, practice your brushwork. Try to control your brush, holding a strong edge and gradually changing a value from dark to light. Limit your brushstrokes and wipe your brush out regularly.

Project:

Step 1 On white paper, draw a rectangle and place some dark shapes in it using a 2B pencil. Make a pleasing arrangement of separate shapes of varying sizes.

Step 2 Lay in a middle value that connects and holds together the dark shapes. Leave some of the paper white for good balance.

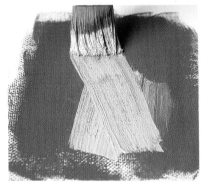

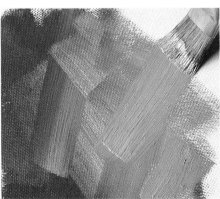

Project: Premix three values of color using burnt umber and white for the project on the next page. Practice your brushwork for edge control and value blending. For cleaner strokes when painting over wet paint, wipe your brushes frequently and limit your number of brushstrokes. Brush control is achieved through constant practice.

Project:

Step 1 Use one of your better dark and light arrangements from the exercises on the previous page. With the middle and light premixed values, lay out the dark and light pattern on a panel of about 12 × 16 inches. If the value pattern suggests some subject or form to you, start putting it in the painting. Use your imagination. You will be painting wet into wet so wipe out your brushes frequently while you work.

Step 2 Start using the dark value now. Think of what kind of form or subject you are painting and try to develop it with some definite edge control. In some places, your brushstrokes will have to be accurate to show the correct form. Other areas will require some overpainting and changing. Do not over brush; leave your brushstrokes alone when trying for a sharp edge.

Step 3 More clarity of edges and values is now needed. Have a clear picture in mind of what you are painting. If it is not clear, study a similar subject from life. Do not just copy a photo. The underlying dark and light pattern should be retained as it gives the painting an important underlying structure. In this project, the important thing to learn is how to keep the underlying value pattern or structure in the painting until it is finished.

Using the effects of light and of grouping different things together into masses of dark or light allows you to build your painting in a unified way.

Chapter Three

Using Color

We live in a world of color. Everything that we see, do and feel is affected directly or indirectly by color. Not only do we depend on our own use and arrangement of color, but nature is continually thrusting its own arrangements into our lives. It is difficult to imagine our lives and world without color.

A painter uses color to its maximum effect. Whether he is using a few or many colors, a good painter knows how to get the best out of them. When used effectively in painting, color not only helps to show form in a fuller dimension, it is also able to express much of the artist's feelings.

Although color by itself has great impact, it is only when it is used in conjunction with a good tonal value foundation that the best is brought out in a painting. As we saw in the last chapter, dark and light value arrangements form the basis of a painting over which good color is built. For control in constructing form or for composing a picture with feeling, always combine good tonal value relationships with color.

In this chapter, we will study what color is and what it can do. We will also learn how to see and use color to get the most out of it in your painting.

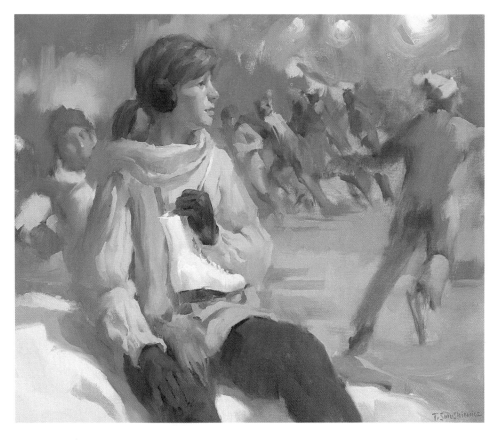

The Ice Skaters, 1990, 20″ × 24″

Light and Its Effect on Color

Color is seen because of the effect of light. Without light there would be no color. Although different objects or forms have their own individual colors, they all depend on the color in light in order to be seen.

Most light, whether artificial or natural, is made up of the full spectrum of color. The primary colors of yellow, red and blue, and the secondary colors of orange, violet and green are present in it. However, all light differs in the proportions of these colors. Thus some light may be cooler because it has proportionally more blue in it, as opposed to a warmer light, which contains a larger amount of yellow and red. A light that includes all the colors of the spectrum, regardless of whether it is on the warm or cool side, can be thought of as a white light.

When white light illuminates a surface that has a certain local color, that color is reflected back to the viewer because it is present in the light. For example, we see a red surface because the light that illuminates it has some red in it to reflect back to us. All the other colors of the spectrum are absorbed by the surface and are not reflected back. If the color of that surface is not in the light that illuminates it, it will not be reflected back to the viewer; it cannot be seen.

White Light Is Made of All the Six Basic Family Groups of Color

The red surface reflects only red back to the viewer. The other colors are absorbed by it.

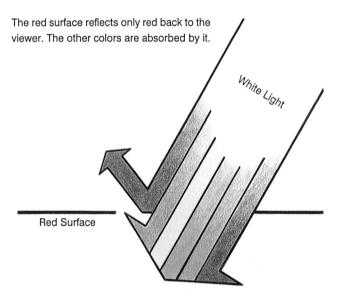

White Light

Red Surface

In order for a color to be seen, it must be in the light. White light shows all colors because it has the full spectrum of color in it.

Warm White Light A warm white light has more of the warmer colors in it. This light will influence a subject's color with yellow, orange or red. Unless a subject's color is extremely weak, it still will be recognizable.

Cool White Light A cool white light has more of the cooler colors in it. This light will influence a subject's color with blue, blue-violet and green. Some of the subject's color will still be recognized, although not as much as in a warm white light.

Understanding Basic Color Principles

The Primary Colors Color, like many other things, has a basic structure on which more complex concepts are developed. Understanding and using this basic structure will help the painter see and mix good color.

All colors, no matter how complex a mixture or how subtle it appears to a viewer, originate in the three primary colors of yellow, red and blue. At equal distances from each other on the color circle, each of the primary colors can be expanded through mixing with one of the other primaries to create the secondary colors of orange, green and violet. The primary colors together with the secondary colors make up the six basic families of color. There can be no more new families of color made beyond the secondary colors. However, the six basic colors can be mixed together to make different variations of these colors. For instance, green can be mixed with more yellow to make yellow-greens or blue can be mixed with it to come up with blue-greens. If there is enough mixing of adjacent colors, an unbroken, continuous ring of hues will be made.

Hue, or Family of Color Most colors as seen in life and nature are not bright and intense. Many colors fall somewhere between full intensity and complete neutrality. However, every color can be identified as belonging to one of the six basic families of color. By determining the basic family to which a color belongs, you will have a dependable and helpful direction to follow for color mixing. The desired color can be found by first eliminating the color families that it obviously does not belong to. This approach is especially helpful in mixing the more neutral grays that are difficult to identify.

Although in color theory the primary colors can be mixed to obtain the secondary colors, there are limits to what the actual color pigments can mix. For instance, no single red pigment can mix into both an intense orange and also an intense violet. You have to use a cadmium red light to mix the orange and an alizarin crimson or magenta to mix the violet. The yellows and blues also are limited in mixing but not as much as the reds. Cobalt blue could be considered a true blue, yet it will not mix an intense and brilliant yellow-green like viridian green and cadmium yellow pale. Since cadmium yellow light is a warmer yellow, it mixes better into an intense orange, while the cooler cadmium yellow pale mixes into the greens.

A well-selected and diversified color palette takes into consideration each color pigment's limitations and provides other pigments that expand the palette's mixing capabilities. The color palette of pigments given in chapter 1 is a good basic selection of pigments that gives a wide range of color mixing.

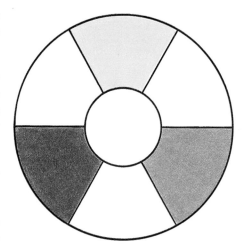

All colors originate from the primary colors of yellow, red and blue.

The yellow, orange, red, violet, blue and green hues or families of color are the six basic colors of the color circle.

If adjacent hues are mixed together, an unbroken ring of hues will result.

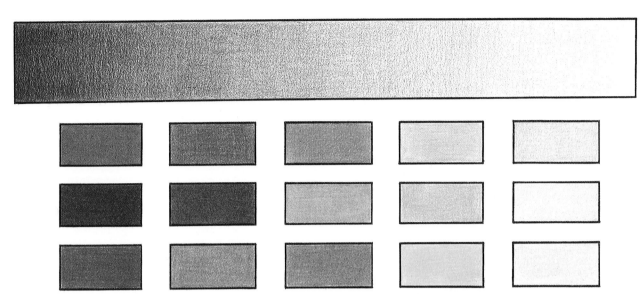

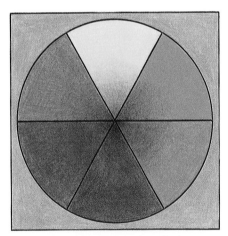

Different colors can have the same tonal value.

Tonal Value The second important aspect of color, after hue, that strongly affects the way it appears to us is tonal value. Every color can be placed somewhere on a dark to light tonal value scale. Only the values of black and white are without color because they are too dark or too light for color to be seen. Even the lightest yellow is still darker than white, and the darkest violet that you can recognize is lighter than black. That is why the darker color pigments of ultramarine blue deep and alizarin crimson appear to brighten when a small amount of white is added to lighten and bring them out of their deep darkness.

Another important tonal value relationship is that many different and opposite colors can share the same tonal value. This sharing of a common tonal value helps to unify a color arrangement by holding or grouping different things together.

Common or close value relationships also help the painter to model using color temperature. Making a form's color slightly warmer or cooler without drastically changing its tonal value can make its surface advance or recede.

Intensity or Saturation Since many colors in nature do not appear intense or bright, much of the color we see is somewhere between neutral gray and a pure intense hue. To mix these subtle variations, a painter must reduce the intensity or saturation of a pure hue.

Like a sponge that is totally saturated with water, a fully saturated color is completely filled with its basic hue or family of color. It shows a color at its brightest and at its greatest intensity. When you mix a completely different color with it, a less intense color results. Colors that are opposite on the color circle are ideal for this purpose because they contain none of the color that is being changed. If enough of an opposite added to a fully saturated color, that color will eventually become a neutral gray.

The intensity or saturation of a color is reduced by adding its opposite. Here, yellow was added to violet; red to green; blue to orange, etc.

Full Intensity

Reduced Intensity

Influence of Surroundings

The appearance of a color is always affected by its surroundings. The same color can look very different when placed in two different areas. Not only will the local color affect how we see something, but what is next to it or nearby also influences its appearance. For instance, a color can look lighter against a darker background or darker against a lighter background. So, changing the surrounding tonal values is one way to alter the appearance of a color without changing the actual color itself.

Placing a color against another color can also alter its appearance. Generally, when opposite colors such as orange and blue, red and green, or yellow and violet are placed next to each other, their individual intensity appears stronger. In mixing and painting color, using opposite colors against each other will enhance the appearance of those colors. This is done by using opposite colors of the same value and mingling them on the painting so they remain partly separated from each other instead of totally mixed together. We will study more of the technique of mingling color later in this chapter.

Making surrounding areas grayer or neutral is still another way of enhancing a color and making it look stronger than it actually is. For greater unified color harmony, choose grays from the same hue or family as the color they surround.

Left The smaller orange square looks lighter against a darker background.
Right The same orange square looks darker against a lighter background.

Left The smaller yellow-green square looks very bright against a darker opposite-red background. **Right** The same yellow-green square doesn't look as bright against a darker green background.

The same red barn, below, doesn't look as bright against the warmer colors in the trees and sky. When colors closely related on the color circle are placed together in a picture, greater harmony is achieved without any of the colors looking much stronger than others. Massing colors of the same dark and light value also helps to unify a picture.

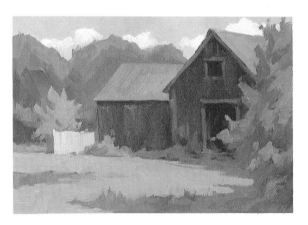

The red barn shown above looks bright against green trees and a blue sky because those colors are further removed and almost opposite from red on the color circle. When placed together in a picture, opposite colors make each other look brighter and more intense. Grayer and less intense colors are still necessary for good color balance in a picture.

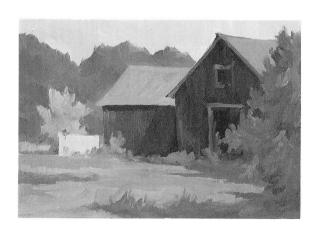

Color in Different Light

We see color because of the kind of light and the way it illuminates something. Each light has an individual color quality that produces an effect on what it illuminates. Therefore, the color temperature of the main light source is an important part of painting.

The two basic divisions of the color of light are warm and cool. Light leans either toward the yellows and reds or toward the blues of the spectrum. A warmer light can appear more yellow, orange or red, while a cooler light can have more blue, green or violet in it.

Because light carries its own colors in it, anything it strikes will be influenced by those colors. A warmer light toward the yellow side will make a green color look yellow-green. That same green will look blue-green under a cooler light that has a lot of blue in it. Sometimes, to achieve a different color effect in a painting, an artist will purposely change the color temperature of the light.

Warm Light

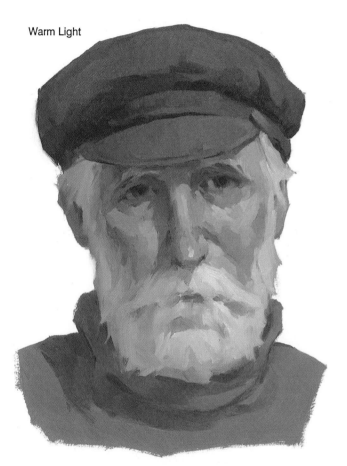

Left Under a warm light, local color in a subject is influenced by the yellow and orange in the light. Local color refers to the actual colors of a subject. Even flesh has its own local color. In warm light, darker shadow areas look cooler and grayer than the lights because the subject's form blocks the warm light from these areas. The uniform color influence from the light throughout the subject helps to hold together all the different colors.

Cool Shadow

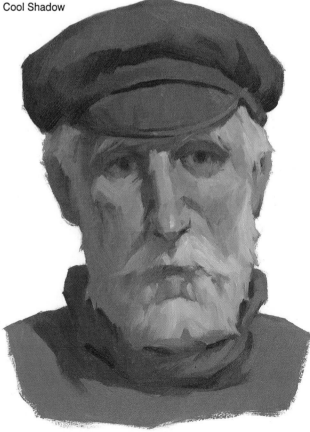

Right Under a cool light, blue and blue-violet are influencing the local colors of this subject. Notice the differences in color in his brown cap, blue sweater and gray beard. With a very cool light, darker shadow areas tend to look grayer and slightly warmer than the lights. Colors will generally look brighter in light areas because there is more light illuminating the surface.

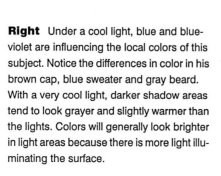

35

Light Temperature and Its Effect on Form

A principal light source coming from one direction is necessary to see form clearly. Since every light has its own color quality, form will be influenced by that color in the light and shadow areas.

In the illustration to the right, the orange box is illuminated by a warm light. Most of the warmer yellows and reds are blocked out of the light by the box's form. Blue remains an influential color in the shadow, making anything in that area cooler and grayer. Because the light is blocked out, the shadow areas also become darker in value. It is possible to create a stronger contrast between shadow and light by using color temperature changes between them. By using more of the right *color* in the shadow areas, the darker shadow values do not have to be too dark or dull. In this way, a more solid looking form can be achieved, one that has a feeling of space around it.

In a cooler light—that is, with more blue in it— shadow areas look warmer but still grayer than the lights.

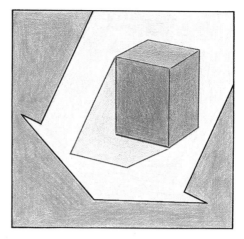

Warm Light

A subject can first be simplified into large flat surfaces that enclose all the smaller individual shapes. As a warm light strikes this simple construction, surfaces that are in shadow and opposite to the light direction become cooler. Cast shadows are also formed that are cooler because the warm light is blocked out.

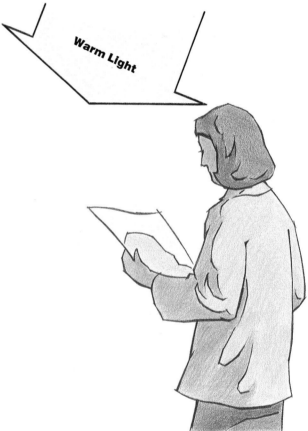

Modeled form is first guided by the direction and color temperature of the light. Remember, local color—the actual color of the subject—is always affected by the color temperature of the light. A warm light will create cooler and grayer shadow areas.

Color Temperature and Form

Light shows us the form of a subject by its direction and also its color temperature. As we know, one main light source striking the many different surface forms creates various dark and light values that help show form.

When color temperature influences these values, additional information is given that can strengthen the modeling of form. With a warm light, surfaces that are receiving light are lighter in value and warmer in color than those surfaces that are between light and shadow. Since warmer colors come forward when placed next to similar colors that are cooler and grayer, a feeling of space and distance is given to a form by using different color temperatures.

The best way to learn to see the difference in color between varied light sources is to paint the same subject in different types of light. For instance, try painting the same simple still life under an ordinary household incandescent lamp, by the natural daylight coming through a window, and in a cool fluorescent light. Don't forget to squint in order to see correct dark and light value relationships.

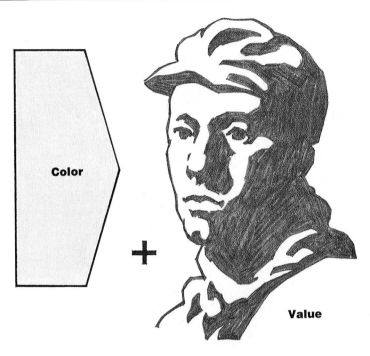

Color + **Value**

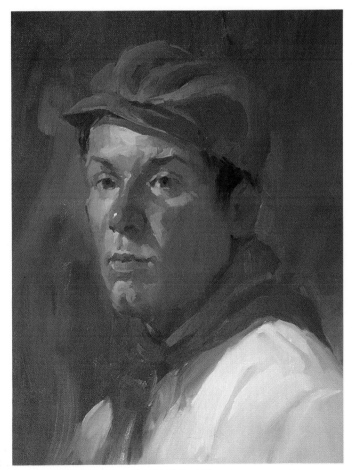

A warm light boldly falls on this subject, creating a strong contrast between light and dark. As colors on the different surfaces turn from light into shadow, they darken in value and become grayer and cooler. Changes in value and color temperature are used in this painting to model form and create the effect of a strong warm light.

Lucian With Red Scarf, 1988, 14″ × 18″

37

Color Balance

Many colors in nature are combinations of colors that range from gray and subtle to pure and intense. The variety of combinations that we can see is almost infinite. However, color pigment itself depends on light reflecting from it to tell us what it is. In order to paint the effect of light as seen in nature, the painter must balance or combine certain elements in a painting to maximize the pigment's mixing effect.

The contrast or balance between dark and light tonal values of different colors helps the painter relate color to form in the early stages of a painting. All representational form is first constructed on a good tonal foundation.

By using warm and cool colors in combination with dark and light values, a good simulation of light can be achieved. Warm and cool colors also enhance the indication of solid form.

The balance between bright intense colors and grayer colors is also very important. Gray colors help to bring out the full impact of the stronger colors by acting as a support for them. They complement the intense colors with their neutrality.

In the painting below, I used an assortment of color grays to balance the stronger and more intense colors. Small areas of intense color need larger areas of gray colors in order to work together in harmony in the same painting. Part of the color balance used in this painting involved the correct contrast between dark and light values and warm and cool colors.

The construction painting below uses a larger arrangement of varied color grays to balance the smaller but more intense yellows, reds and blues.

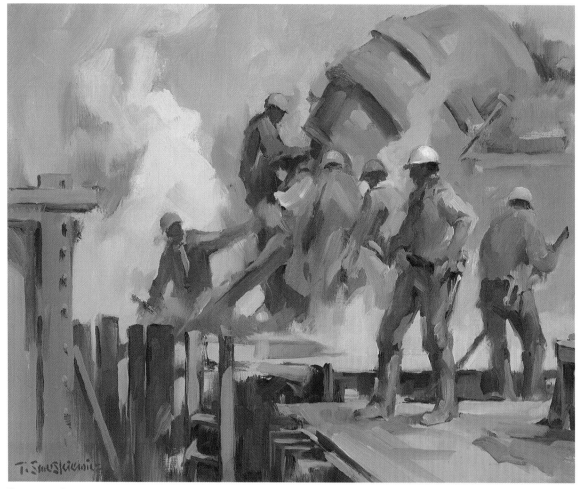

Construction, 1990, 8″ × 10″

Color Harmony

Color harmony describes an arrangement of hues, or families of color, that gives a pleasing appearance in the painting. Colors can be closely related on the color circle, or they can be far apart and on opposite sides. The closer that the colors are on the color circle, the more unified the color harmony will be. However, unless some other color is added that stands somewhat apart from the other colors, the harmony can become static and lack vitality.

Several variables influence the development of a particular color harmony. For one thing, the color and type of light illuminating a subject has a strong effect on its appearance. Light always gives some of its own color to the subject's color.

Another important influence is from the local color of the subject itself. Local color is a necessary part of a color harmony scheme because it helps identify the subject that you are painting. If you are painting a yellow house against some green trees, yellow and green colors must be used in the color harmony; otherwise, the subject will look different. Although you can change the local color of part of the subject to enhance or improve the picture's color effect, with some subjects, changes are made at the risk of losing the original idea. When deciding on a color harmony plan, many times it is best to trust your first impressions of color.

In the painting shown below, I used orange and blue, balancing these colors against large areas of colorful grays. This subject called for vitality and contrast to show the effect I wanted. Since orange and blue are direct opposites on the color circle, they gave me the color contrast that I needed. The plain blue sky and dark shadow areas act as a balance against the busier and more complex forms found in the bluffs.

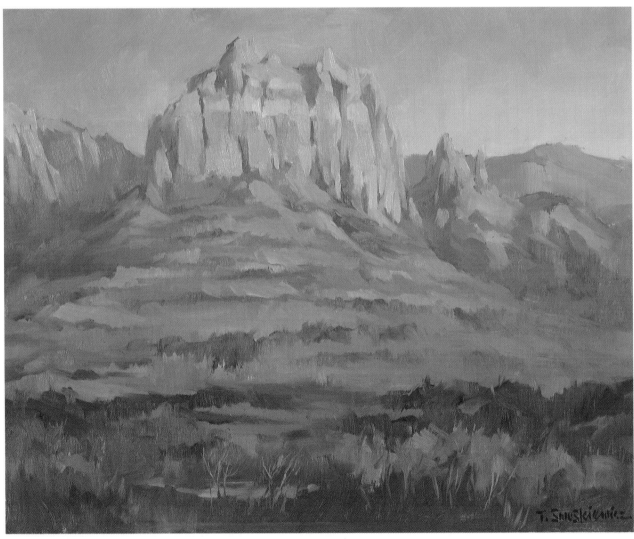

Sedona Bluffs, 1988, 11″ × 14″

Dominant Color Harmony

An effective way to develop and control color harmony is to use a dominant color scheme. In this approach, one basic family of color is used initially to develop a subject. As the painting starts to come together, other colors are introduced to complement and enhance the original color.

What we see is greatly influenced by the color of light. This unity of color influence, no matter how subtle, makes a dominant color scheme a good approach. If you are impressed with a certain color effect of light, why not use it to develop a painting?

When starting a dominant color scheme, begin with one basic color family but balance it against grayer colors and neutrals. A good tonal value construction is also necessary at this stage in order to establish form and a light effect. The next color introduced is often from directly opposite on the color circle. Colors adjacent to the original dominant color are then introduced. For the best effect, always keep the dominant color the most influential.

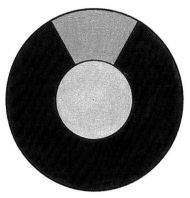

The first step in this painting uses only the dominant color of blue, which is balanced against neutrals and grays. Dark and light values are also correctly put in for a solid form and light effect.

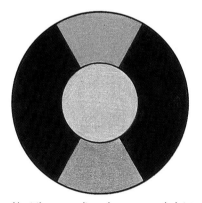

Next the opposite color, orange, is introduced into the painting as a balance against the dominant color of blue. Using neutrals and color grays plus good value control is still important in developing the painting.

This analytic illustration clearly shows blue as the dominant color in the painting shown on the opposite page. Notice how little the opposite color of orange, in its most intense form, is used as a balance against blue. The adjacent colors of green and violet, although present throughout the painting, do not take away from the original dominant color of blue because they are not as intense.

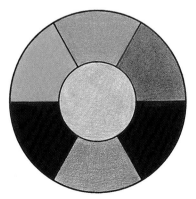

Green and violet, which are the colors adjacent to blue, are now painted into the picture. In this type of harmony, remember to keep the first dominant color as the main color influence.

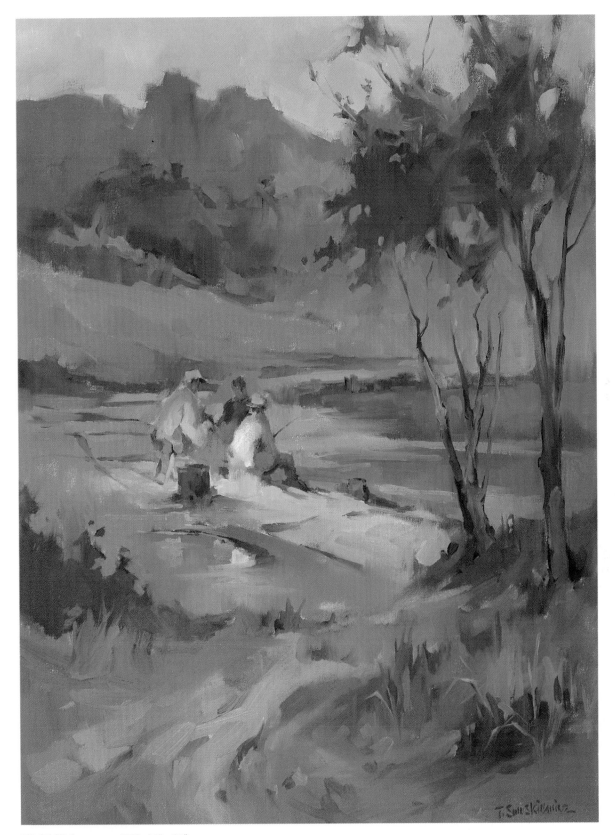

Night Fishermen, 1990, 18″ × 24″

To get the full impact of night in this painting, a dominant color of blue with its adjacent colors of green and violet was used throughout the picture. The opposite and lighter intense orange color enhances the night effect. Grays and neutrals are important balances that hold everything together.

Learning to See and Mix Good Color

Hue Seeing and recognizing the correct hue or family of color is the first step toward mixing it. By first eliminating the color families that obviously do not fit, it becomes easier to recognize the correct hue. In this picture, the red family is used because that is the basic color of these apples. Color grays of red are used as a background for support and balance to the stronger red in the apples. When starting a painting, always put in some of the background next to the main subject. This makes it easier to see the subject's correct color. Premix all the colors on your palette to use as base colors for blocking in this first stage. They will also provide you with beginning color mixtures for further mixing.

Value The correct dark and light tonal values are painted next. Only by using value can you construct form and create a feeling of light. Notice how some edges are hard and some are soft. This enables the round surface of the apples to be clearly shown.

Some gradation of values and color is painted into the first flat colors of the background to give them interest and unity. The same family of red in the background grays pulls the picture's color harmony together but still gives enough contrast to enhance the red apples. Working with values, edges and modeling helps to establish a definite light effect.

Intensity Color intensity variation plus warm and cool color contrast give this picture its final appearance. The way color looks in a subject always depends in part on the color of the light. With a warm light, as in this picture, an orange-red color is introduced into the lighter areas while the shadows become darker and slightly cooler. Strong highlights help to complete the round form of the apples. Practice painting subjects like this directly from life to learn to see and mix good color. Always use a definite light source as from a lamp or window when doing practice studies for color.

The Palette and the Color Circle

Since there are only six basic families of color, placing your color pigments on the palette in their correct position on the color circle is an excellent way to see their relationships with each other. As long as a definite color family can be seen in a color pigment, its proper place on the color circle can be found. Intensity or brightness of color in a pigment has nothing to do with its placement. For instance, terra rosa can share the same orange-red place on the color circle as cadmium red light. In the same way, the very cool ivory black shares a place with cobalt blue. Once you know the position of the color pigments, their relationships in mixing can be seen. Any color pigment belonging to the blue family, for example, will always give some kind of green when mixed with yellow family colors.

Placing your colors on the palette in this manner helps give you control in color mixing. If the warmer yellow and red pigments are placed together on one side of the palette and the cooler green and blue pigments on the other side, then the color pigments are in the basic relative position they are on the color circle.

Lay your colors out on the palette just as they are positioned on the color circle for easier mixing control. Keep the warmer yellows and reds on top and the cooler blues and greens on the side. Place your white in the corner.

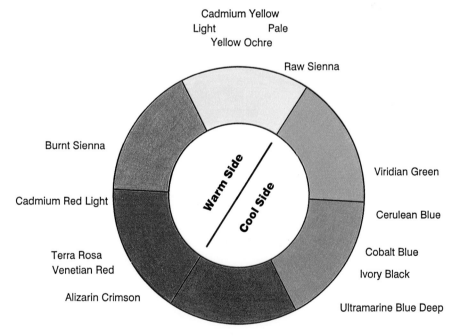

All color pigment can be placed somewhere on the color circle. Several color pigments can share the same place because they are basically of the same color family. For instance, cadmium red light, terra rosa and burnt sienna are all positioned close together on the color circle. Even though they are different in appearance, they are of a similar color family.

By having color pigments on your palette that are both warm and cool and knowing their relative position to each other on the color circle, much more control is possible in color mixing. If you want a bright and intense color, you must use bright and intense pigments. If you want a grayer version of the same color, add a little pigment from the opposite side of the color circle. When choosing pigments to mix together, first determine their position on the color circle.

Color Mixing: Hue, Value and Intensity

Seeing a color clearly is the first step in good color mixing. Working directly from life, whether in a simple still life or a more involved subject like a landscape or portrait, is the best way to learn to see color. First, identify the basic family of color or hue. Then find the tonal value of the color. This will give form to the subject and also help to show the effect of light. Don't forget to squint at your subject when working from life in order to see correct value relationships. Many colors will require some adjustment by mixing to find the exact intensity. To reduce or gray a color's intensity, always mix it with a color from the opposite side of the color circle. Try to compare a color that you are mixing against a stronger version of that color. Comparing one color against another is still the best way to judge it.

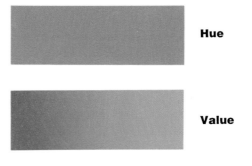

Hue

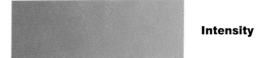

Value

Intensity

When you begin a painting, concentrate on working with basic families of color (hues) and dark and light tonal value construction. This way, a feeling of form and light can be established early. In this picture, green is the dominant color that finds itself in almost everything. A good sense of light and shadow is achieved through the use of dark and light values.

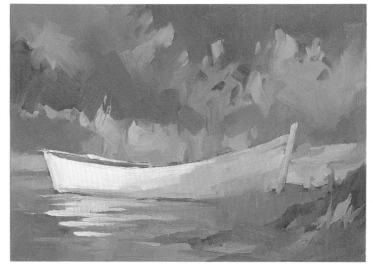

Changing the intensity of some of the greens by introducing some red into the color mixtures and introducing more subtle values in modeling now gives the picture increasing depth and form. Control of hard and soft edges is an important part of finishing a painting. Compare these two pictures to see how edges helped to develop a more finished look in this one. Green is still an important part of the color harmony, but now its intensity has been varied to develop more form and space.

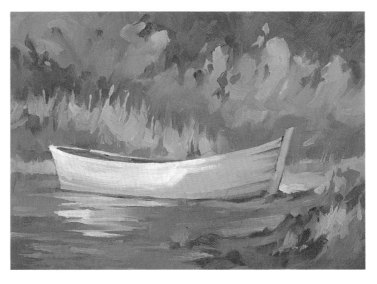

Finding and Mixing Shadow Colors

Colors in shadows have three basic characteristics: A shadow is always darker than the lighted areas; a shadow has some of the local color that is more clearly seen in the lighted areas; shadows are grayer and less intense than lighted areas because they receive only reflected or incidental light.

To mix a shadow color, first find the subject's color in its lighted areas. The color temperature or color of the light will influence the local color of a subject, the actual color of the subject's surface. If the light is warm, for instance, the local color will also appear warmer in lighter areas. The shadow areas are made darker in value and grayer by mixing in some of the local color's opposite color. If the light is warm then the shadows should be cooler. Study shadow colors from life using a simple still-life arrangement under different types of light. In general, standard incandescent bulbs will produce warm light, whereas fluorescent bulbs produce cooler light.

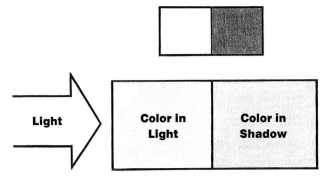

On the left is the light area's local color. Once you have established that, find the shadow's correct dark value next.

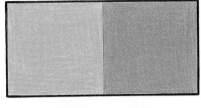

The local color seen in the light areas should also be present in the shadows but as a darker value.

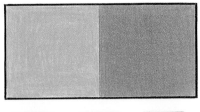

A shadow is grayer and less intense in color than the light areas. Gray the shadow by adding some of its opposite color.

A shadow on flesh can be made out of the primary colors of red, yellow and blue. Using a medium red color pigment, first find the shadow's correct dark value.

Add a darker yellow ochre to the red to bring it into the same color family as the lights.

The opposite color pigment, blue, is added to the shadow color to gray it. The shadow is also made a little cooler because the lights are warmer.

Painting With a Limited Palette

As we have seen, the effects of light have a strong influence on the appearance of color. Light creates dark and light values that show us form and it also gives its own color to the subject. These two important influences can be explored with a limited color palette. A color palette refers to the color pigments you use to paint.

You can use as few as two colors plus white. If two color pigments are selected from color families on opposite sides of the color circle and they are dark enough in value, then a painting can be created that has both a full range of values and color temperature.

This will give the picture good form and a definite lighting effect. The earth reds such as terra rosa, venetian red or burnt sienna make excellent warm color pigments. Cobalt blue, ultramarine blue, viridian green or ivory black are good cool pigments to use. Avoid using cadmium yellow or orange as they are too light in value for use in mixing deeper darks. When working with a limited color palette, you are restricted to certain color families. However, solid form and an indication of light are still possible. Use a limited palette in studies directly from life to learn to see how light affects the appearance of form.

Mixing a warm terra rosa and a cool cobalt blue, with white added to lighten the values, gives a wide range of color mixtures.

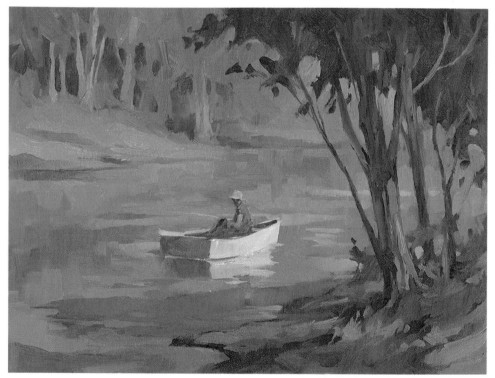

Although it restricts the number of color mixtures possible, a limited color palette can still give excellent results. By using color pigments that are nearly opposite on the color circle and dark enough in value, form and light can be described. Terra rosa and cobalt blue were used in this picture. These pigments are from almost opposite color families. When using a limited color palette, good drawing, edge control, and a well-balanced dark and light construction are especially important. Good paint application also improves the painting's appearance.

Three-Color Limited Palette

Since all color originates from the three primary colors of yellow, red and blue, good control in mixing color can be achieved using only these three color pigments. In a three-color limited palette, almost any type of yellow, red or blue pigment can be used effectively. Intense and bright pigments can be used with less intense pigments. When selecting pigments, make sure that at least two of the pigments are of darker value. Usually these are the red and blue color pigments. This will allow you to obtain more variety of color in the very dark passages. If the only dark value pigment is blue, then the painting's darkest values will also be blue.

Painting thumbnail sketches from life using a three-color limited palette is an excellent way to study color. When selecting a combination of color pigments for use in a limited palette, first study your subject carefully to pick the best pigments for the effect you desire. Once again, when making studies directly from life, it is important to squint at your subject to be able to see correct value relationships of all the different colors.

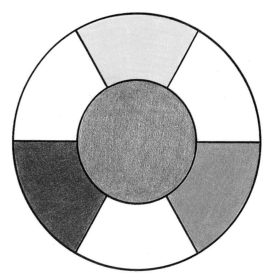

Select color pigments for a three-color limited palette from the primary color families of yellow, red and blue. Make sure that at least two of the color pigments are dark enough to give some variety to your dark colors.

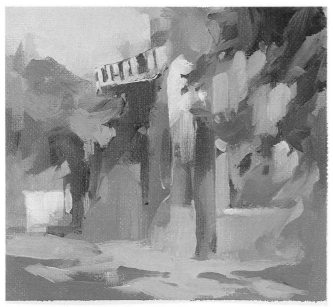

Doing color thumbnail studies, either from life or imagination, is an excellent way to explore the use of a limited color palette. I used a darker yellow made by mixing cadmium yellow light and yellow ochre for both of these thumbnail sketches. For red, I used a mixture of cadmium red light and some alizarin crimson. For blue, the cooler ivory black was used. Each study is first built on a balanced arrangement of dark and light values.

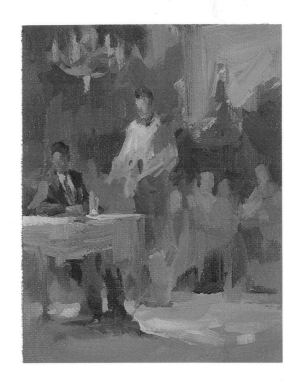

47

Color Techniques

Good color technique is not built on clever paint handling or other tricks. A well-executed painting uses sound principles of color application. Using a brush and painting knife are proven approaches to applying oil paint that allow much versatility in handling and easily incorporate all the sound principles of good color use.

Color mingling is a good way to show the brilliance of color as well as the subtlety of color grays. In color mingling, colors are not totally mixed together. Some of the original hues remain separated, allowing a visual blending. Color pigments may be applied with a brush or painting knife, using wet-over-wet or wet-over-dry painting approaches. The color pigments should only be partially mixed on the painting's surface. When a brush that is loaded with paint is applied directly onto a wet surface, some of the wet undercolor mingles into the wet color being brushed in. Therefore, in wet-into-wet painting, frequent wiping out of the brush is important in order to keep your colors clean and not muddy.

In the scumbling technique of wet-over-dry painting, the fresh wet color pigments are mingled over the dry color below. This is done by partially brushing over the dry undercolor, leaving some of the color showing through.

Even brushing together of a warm and cool color gives a gradual and subtle blended effect.

Using a brush to mingle the same two colors allows the warm and cool colors to visually react with each other.

A painting knife gives a bolder mingling effect with crisp edges to the same warm and cool colors.

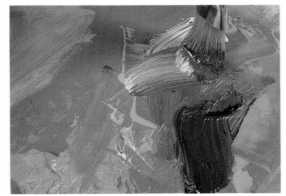

Don't always blend your colors too evenly. Let your brush partially blend or mingle colors.

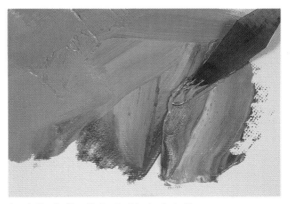

A painting knife will give bold mingled effects of color if the stroke is left alone. Avoid the natural tendency to smooth out your strokes.

Color Mingling With a Brush

Painting into a wet surface produces a natural mingling of color. In the illustrations above, the first stroke on the left has the strongest warm color. As the next two strokes are made into the wet blue paint (right), more of the blue begins to mingle with the warmer color, thus reducing its intensity. If the strokes were continued, the color would eventually blend together into an even gray mixture.

Using painting medium with your colors allows you to achieve a softer mingled effect as you brush into a wet underpainting. (Refer to chapter 1 for a discussion of making and using a painting medium.) Here, after the brush was loaded with a yellow color from the palette, it was dipped into some painting medium and then freely brushed out into the wet blue paint. A soft mingled effect will result if you take care not to overbrush your colors.

I painted this picture outdoors, directly from life. Working rapidly because of the changing light, I brushed in my colors boldly, letting the wet paint mingle freely. I wiped out my brushes frequently in a paint rag to keep them clean. Brushstrokes were left alone in the foreground to achieve the crisp, sunny look but were allowed to blend together naturally for the colorful shadow areas.

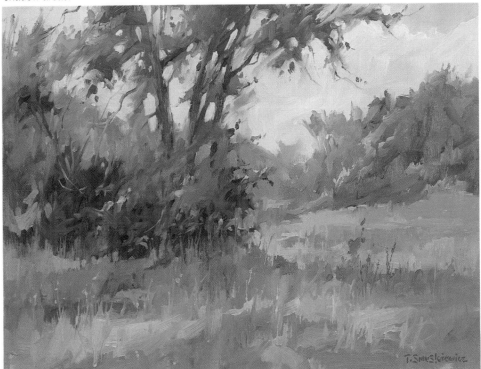

Grass and Woods, 1989, 12" × 16"

Color Mingling With a Knife

Lay in your first strokes boldly. Spread the color evenly but not too thickly. Don't be concerned if a few small areas are not covered. Let some of the underpainting show through in places for a mingled color effect.

When applying a different color to wet paint with a painting knife, take advantage of interesting partially-blended effects but don't overblend.

A much lighter color is applied along the edge and partly into the wet underpainting. If the knife stroke delivers a thicker amount of paint, there is complete coverage of the color underneath. A sharp edge can be achieved by leaving the stroke alone.

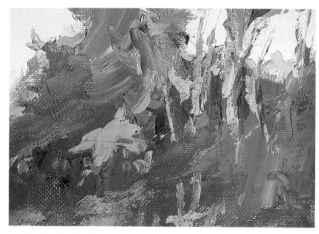

In this detail of knife technique, the red-brown underpainting can still be seen. Notice how some of the olive green colors were boldy applied and allowed to mingle together. Heavier applications of light yellow were laid in at the top to form a good edge and contrast. Be ready to keep any interesting effect that may occur.

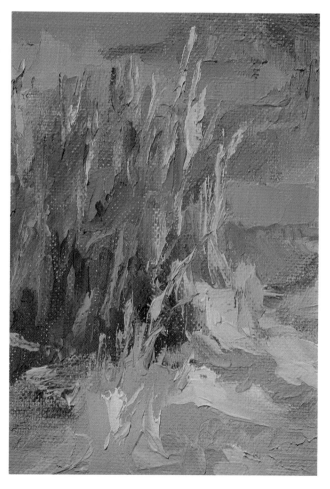

This detailed section shows several ways of applying color with a knife. First a warm underpainting of medium value was laid in flatly and thinly. Heavier applications of olive greens were laid in over the wet underpainting, partially blending. A lighter yellow-green was added. Knife strokes were kept thin and sharp-edged in some places to suggest grass.

Brush and Knife Color Effects

Applying oil paint with a brush and a painting knife are two basic ways of painting. Each lends its own individual color effect. A brush breaks down the surface with a distinctive stroke that tends to reflect light. If a painting medium is used, the oil paint lays flat without surface texture and even becomes somewhat transparent in places. Edges are easy to soften, especially when using a filbert or round bristle brush.

When oil paint is applied with a knife, the surface is smoother, showing more of the true color. Gray colors become more vivid. The natural effect of a knife stroke is to give sharp edges and crisper areas of color. Taking advantage of a brush and knife's individual qualities allows the painter to use a wider range of color effects in the same painting. Oil paint can be applied with a brush and then worked over with a painting knife. Using a knife, heavier passages of oil paint can be applied directly over thin and almost transparent areas that were put on with a brush. Colors are easily mingled for impressive color effects.

I started this painting with a brush. Using painting medium, I covered the entire picture with large areas of thinly applied color while I developed the overall composition. Then I began to put on some of the middle range of color with a painting knife. Lighter areas in the foreground and middle ground were laid in heavily over the still wet underpainting. A brush was used to break down the sharp edges and also put in linear strokes where needed. A painting knife was used again for bold strokes.

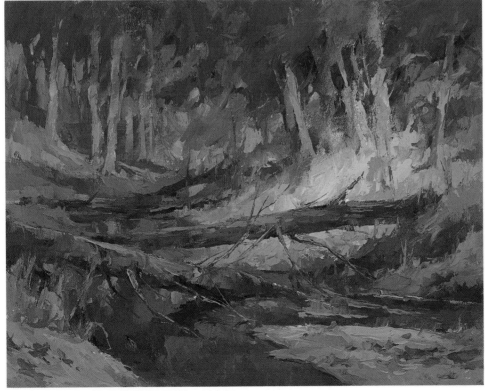

Autumn Forest With Stream, 1991, 11″ × 14″

Demonstration: Color Block-In

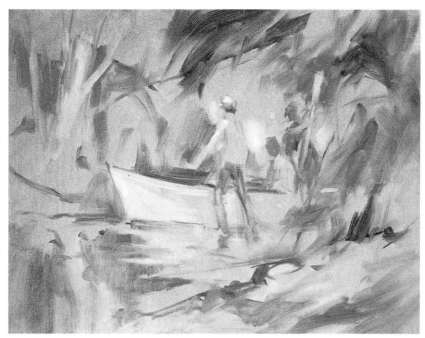

Step 1 I first apply an overall tone to the canvas and sketch in some of the important lines and dark masses. At this stage I am basically interested in establishing a well-balanced foundation in line and mass for later overpainting in color. The idea of starting with a toned canvas is covered in more detail in chapters 4 and 5.

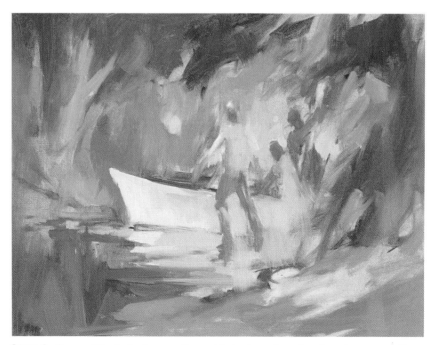

Step 2 Some of the first colors are then added using a large brush and some painting medium. I work throughout the picture on different parts of the subject. As I put in these first colors, I balance them against each other. These first colors should relate clearly to families of color on the color circle. In other words, put your colors in a little stronger so they are easier to identify.

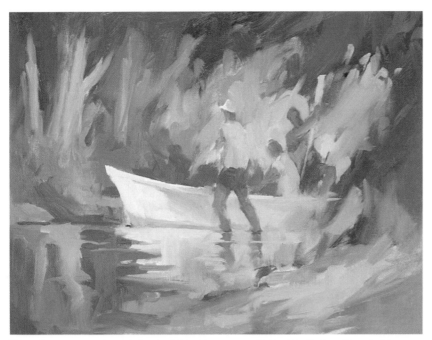

Step 3 More color is put in but individual forms are still simplified in handling. At this stage, I try not to get too involved with finish detail. My main effort now is to establish a good effect of light and get all the important parts of this picture to hang together with color. I apply the colors making sure all the forms are constructed soundly. Remember, all good color begins with good dark and light tonal values.

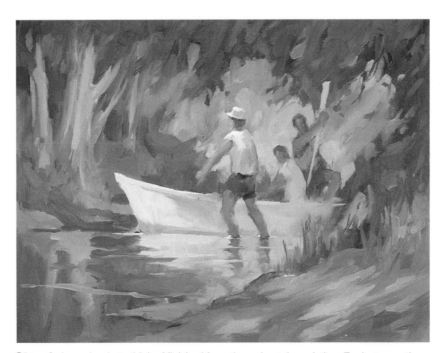

Step 4 I now begin to think of finished form throughout the painting. For instance, the trees, boat, water and foreground all require additional work. The figures in the boat are also important and need to be studied to make sure that they are painted correctly. Overpainting with subtle variations of color and good control of edges helps develop more finish in this painting.

Glazing With Color

Another effective color technique is oil glazing. In this approach, transparent layers of oil color are applied over a dry underpainting, allowing some of the underpainting to show through. The oil color is diluted with a glazing medium. A standard glazing medium can be made by mixing two parts mineral spirits or turpentine with one part linseed oil and one part Damar varnish in a small bottle. In glazing, dark and light value relationships and color in the underpainting have a strong influence on the painting as it develops. The glazing technique gives brilliance to color mixtures and also much control in developing the painting. It is an indirect approach to painting; that is, the first stages will not necessarily look like the final finished painting.

The underpainting should be kept lighter in value than the finished effect desired, because as oil glazes develop the painting, values begin to darken. Excessive color in some glazes can be removed with a soft rag, allowing more of the underpainting to show through.

Since the underpainting and first glazes have to be dry before more glazes are applied, a fast-drying glazing medium should be used if possible. When mixed with regular oil colors an alkyd painting medium speeds up their drying considerably without adversely affecting the painting. Alkyd painting mediums are readily mixable with oil colors. They are nonyellowing and can be thinned with turpentine or mineral spirits.

A tonal value underpainting is the first step in developing a painting with transparent oil glazes. In this simplified illustration, terra rosa and white were used for the underpainting. Avoid putting in excessive detail at this stage. Keep the underpainting a little lighter in value than the finished painting will be. As successive oil glazes are applied, values will become darker. Since the underpainting must be dry before glazes can be applied, paint with a quick-drying painting and glazing medium. The same glazing medium can be used to apply the other glazes.

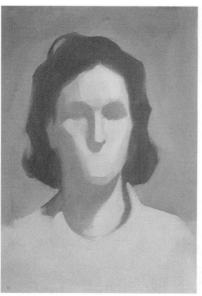

In this second illustration, a yellow glaze was applied over the face and across one side of the value rectangle. Some of the excess yellow paint was removed by gently wiping the surface with a soft, clean cotton rag. Painting a transparent oil glaze of color over an underpainting of tone or color like this is the basic procedure used in glazing. Another way to develop form and color is to paint in some opaque colors in the lights and some deeper tones in the darks.

A green-blue glaze was applied over the background and the hair. The glazing color was thinned with a quick-drying oil glazing medium. An alkyd painting medium works fine for this procedure. Notice how the dark underpainting of the hair shows through the glaze and darkens it. The warm red color in the background underpainting still influences the newly applied cooler glaze. Some of the hair's lights were wiped out, bringing up the slightly lighter and warmer underpainting. The same glaze was also painted over the other side of the value rectangle to show the difference between underpainting and glaze.

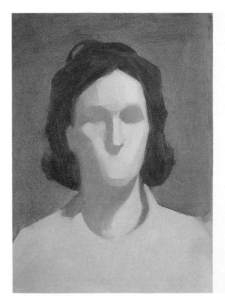

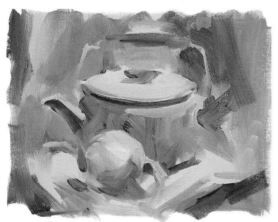

A tonal underpainting is the foundation on which color glazing is developed. In this stage, detail is not important and values should be lighter than for the finished piece. For this demonstration I used an earlier tonal value study for the underpainting.

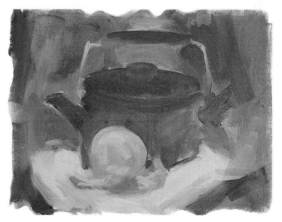

The first color glazes are painted in freely, guiding on the underpainting and gently wiping off some of the color with a soft rag to allow tonal value to come through where needed. Notice how the color begins to separate individual objects.

Color is added as glazes and edges are defined more clearly. Opaque light areas are painted in, and deeper darks are put in to help show form. Some of the underpainting is still visible at this stage. Try to visualize what you want the final colors to look like. Overpaint with opaque colors to help develop some of the lighter forms. Color glazing usually has its fullest impact in showing middle tones and darks. After this stage has dried, another application of oil glazes will help develop more form. Defined edges and strong darks also help to bring out the form.

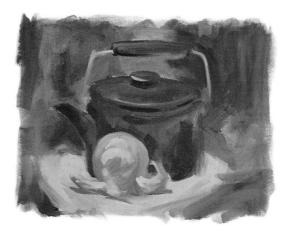

Project Using Color

The first part of this project consists of color value and temperature studies. On a 12 × 16-inch panel, lay out an arrangement of 1¼-inch squares as shown, using ¼-inch masking tape to construct the squares. Select two color pigments from opposite sides of the color circle. Refer to the color circle chart of pigments on page 43. Using a brush or painting knife, place the warmer color in one upper corner square and the cooler color in the other. Beneath each one place a gradated series of value mixtures made by mixing with white. Mix both warm and cool colors together for the center row neutral gray. Mix white with it for the lighter values below. Now mix the neutral mixture with the original warm and cool colors and also mix them with white to fill in the lighter values below. Be sure to save all these individual mixtures on your palette. Along the side, paint two small thumbnail

sketches from life or imagination. Use the color mixtures that you saved on the palette. Try not to be too detailed but attempt to show a good lighting effect with value and color temperature. Repeat this exercise with other warm and cool colors.

The final part of the project will be to paint a subject using a dominant color scheme. You may work from life or your imagination. Begin your study around one main color balanced against neutrals and color grays. Then introduce the opposite color and the adjacent colors. As these other colors are brought into the painting, try not to lose the dominant color effect.

You should also practice color mingling using a brush and painting knife. Use different combinations of value and color temperature in your color pigments.

Project: Two color pigments, each from opposite sides of the color circle (refer to color circle and palette on page 43), are used in this exercise. Place each one on opposite sides of the chart and mix them together to get the colors between them. Reduce all mixtures with white for lighter values and save all mixtures on the palette. Paint two thumbnail sketches along the side of this chart using only the color mixtures from the palette. Repeat this exercise with other warm and cool color pigments.

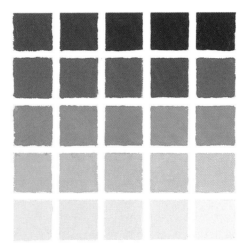

Project: Since the color mingling technique is a good way to achieve vibrant color effects, try practicing color mingling with different combinations of pigments. At first use similar value but opposite colors. Then work with different value but opposite colors. Use a brush and knife as shown earlier in this chapter. Remember not to overblend your colors but to let them only partially mix together.

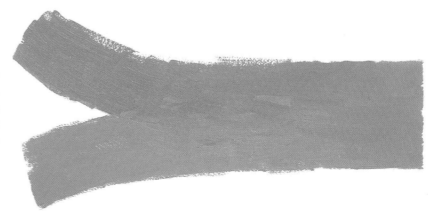

Project: The final part of this chapter's project is to develop a dominant color harmony painting. On a panel of about 12 × 16 inches, lay out the dark and light areas of your subject. You may start with a line and then fill in the dark masses or tonal areas. The tonal foundation of a painting is a very important beginning step. (Refer to chapter 2 for help in putting together dark and light masses in a picture.) If you use a photo, don't just copy it but try to make something original that reflects your ideas. For this first step, I used a mixture of terra rosa and a little blue and then thinned it with some painting medium. Since my color harmony is based on orange, I kept this first step somewhat warm.

In this next step, I used orange as the dominant color in many different values and intensities. The dark value masses still hold together because they were matched and painted directly over the first tonal value drawing. Neutral or color grays were added to balance the more intense and bright colors. Every good color harmony must first be balanced against good tonal values and color grays.

In the final step of this painting, I introduced the opposite color, blue, and the adjacent colors, red and yellow. This addition made the shadows cooler and grayer. More variety of color is now possible in the painting, giving it more interest. Control in painting edges helps to develop more form and strengthens the effect of light. As other colors are introduced into a dominant color harmony, it is important to ensure that the original dominant color remains the most influential.

Chapter Four

Painting Techniques

In the first three chapters we have studied some basic techniques of oil painting as they relate to material, tonal value and color use. Another important part of the oil painting technique is how the paint is actually put on the painting's surface. In this chapter we will concentrate on learning two basic ways of painting: with a paintbrush and with a painting knife.

Of all the different ways of putting oil paint on a canvas, using a brush or knife is still the most popular. The thick, butterlike consistency of oil paint, as well as its ability to be used in fluid washes, makes a brush or knife a natural choice for working with it. Only a brush or knife is versatile enough to take full advantage of all the different qualities of oil paint.

A brush's first use in painting comes in the beginning drawing stage. In the painting shown below, some indication of the picture's design and individual forms was first put in with a brush and some thinned-out colors.

Dark and light value construction as well as important edges were stressed in this first drawing. This provided a guide for applying color directly with a painting knife. By using a painting knife to put on the oil paint, I was able to achieve the vibrant and sparkling effect of light that I wanted. Notice how I played up the bold contrast of color application with a knife over a solid tonal value arrangement.

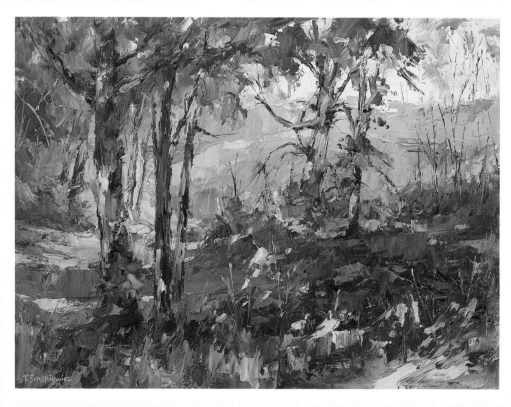

Autumn Landscape, 1985, 12″ × 16″

Using a Brush and Knife

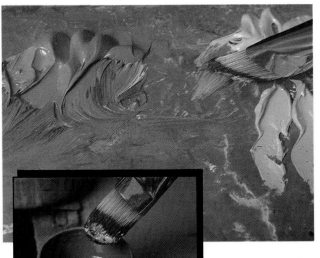

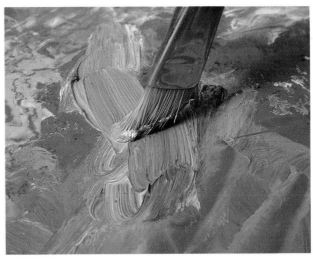

The natural consistency of oil paint is thick and butterlike. Its heaviness allows it to keep a good amount of surface texture, which can add to the aesthetic appearance of a painting. The picture to the upper left shows the natural thickness of oil paint as it is laid out on a palette and how a bristle brush picks some of it up. By dipping a loaded brush directly into a little painting medium, a longer brushstroke can be made that still keeps some texture in it. The pictures to the left and directly above show a bristle brush loaded with two colors, yellow and dark blue, and how some painting medium is used to extend the stroke.

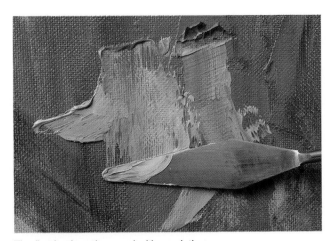

The first basic action used with a painting knife is *spreading*. One or more colors are picked up on the flat bottom side of a knife. A stroke is made by applying light pressure and gently lifting the forward edge of the knife's blade, spreading the thick paint out from beneath the flat blade. If two or more colors are picked up, a partial blending of colors takes place that gives vibrant color effects. Apply less pressure if a heavier layer of paint is desired and more pressure to spread the color out thinly. A knife stroke can be used in several different directions to spread color out in interesting ways.

The second basic action used with a painting knife is *scraping*. By holding the forward edge of the knife downward and firmly against the painting's surface, a forward stroke is made that lifts up the wet paint. This scraping action is similar to that of a snow plow. When scraping wet paint off a painting, some of the color remains embedded in the surface. This allows overpainting with a different color. If the scraped surface is painted into with a brush while it is still wet, some interesting effects can be achieved. Scraping can also soften edges or lessen the harshness of a color.

Step-by-Step Demonstration

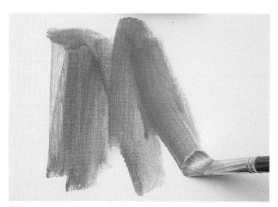

Step 1 To start a painting, apply a grayed color to the white surface. Some painting medium makes it easier to spread colors and cover the surface fully.

Step 2 Then use a rag to wipe down the surface, making an even middle tone that is not too wet. It is not necessary to make a perfectly even tone. A toned surface makes it easier to find the right colors later.

Step 3 With a small brush, possibly a no. 2 filbert, do a line drawing using some of the original toning color with a little painting medium. Avoid detail in the drawing; indicate only the larger forms and important edges.

Step 4 With a larger brush, like a flat or filbert, pick up a darker color and brush in some of the darker masses as shown below. I used yellow ochre, a little cadmium yellow, and ultramarine blue deep to keep the color of the trees and shrubbery in the green family. Keep some of your edges soft, and don't use any white yet. Lighten areas by rubbing off the paint with a rag.

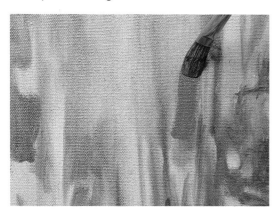

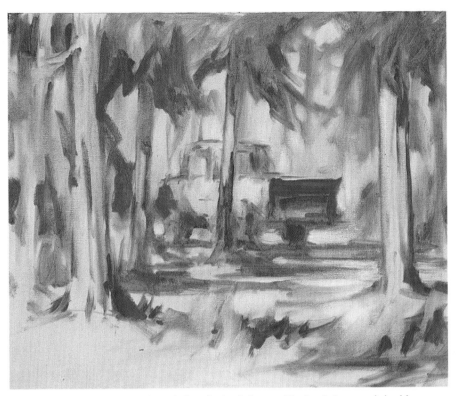

Stage I In this first stage of the painting, the basic forms of the truck, trees and shrubbery have been established. Besides the green color used to sketch in these first forms, some red-brown color is also worked into the picture. This gives contrast to the greens but also helps to build up a warmer base color for later overpainting. Notice how the first color tone that was placed in at the beginning of the painting is still influencing it. This color tone not only gives unity to everything, but it also provides a good foundation for future color use. If this first tonal drawing shows all the basic light and dark areas with all important edges accurately put in, then a good effect of light will be established early.

Detail This shows some terra rosa being brushed into the still wet tonal painting. By painting a red color into the green, greater interest and vitality are achieved. Some of this red color will remain as it is and some will be overpainted later.

Detail After all the terra rosa has been brushed in where needed, some heavier and more intense yellow-green (viridian, cadmium yellow and yellow ochre) is worked into the foliage. To build up good brushwork no painting medium was used.

Step 5 Different colors are now mixed to bring out more form. This shows some of the background's lighter blue-green color being brushed against the darker green foliage in order to show its edge clearly.

Step 6 A lighter yellow color is brushed into some of the darker passages between the trees to open them up and introduce a different color into that area. Leave your brushstrokes alone.

Step 7 Some lighter blue-green is brushed in the background around the back of the truck as a base color for future over-painting. A few strokes of a darker blue-green were also brushed over the darks originally put in around the truck.

Step 8A A few definite brushstrokes of a lighter yellow color begin to define the grassy area in the lower right. Some of the strokes are made by dragging the brush directly across the darker green under-painting.

Step 8B Using the flat width of a brush, a yellow color is brushed across the top of this area to put in a well-defined edge. The brush is well loaded with paint and dipped into painting medium first before making this stroke.

Step 8C This picture shows the same stroke being dragged across the adjacent area. Notice how more of the paint was de-posited at the beginning of the stroke. These first contrasting brushstrokes bring out some of the basic underlying form and should not be overworked. Try to keep good edges.

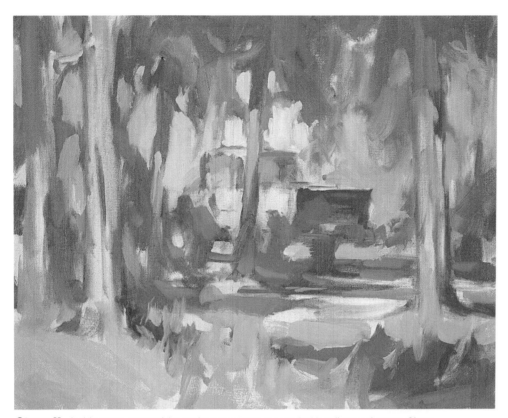

Stage II At this stage, most of the surface has been covered with yellow and green. Since the painting's color harmony is based on these colors, it is essential to begin the painting's block-in with them. Red and blue colors have also been introduced as a balance to the predominant yellow and green. The light and dark tonal pattern that was sketched in at the beginning is still visible, but now has much more power because of the colors already laid in. Notice how important some of the edges are for depicting form. Remember, edges are separations between different tonal and color areas of a painting. Sometimes they are well defined and at other times they seem to be lost and hard to find. Right now detail is not as important as establishing a solid foundation of tone and color for future painting.

Detail A well-loaded brush is used to lay in some of the yellow color of the foreground. Some painting medium helps the color flow easily. The original underpainting is still visible in places, giving contrast to some of the lighter yellow edges.

Detail A distinct brushstroke is used to define the lower part of the truck by painting the lighter background, leaving the darker area for the truck. Leave your brushstrokes alone when bringing out form.

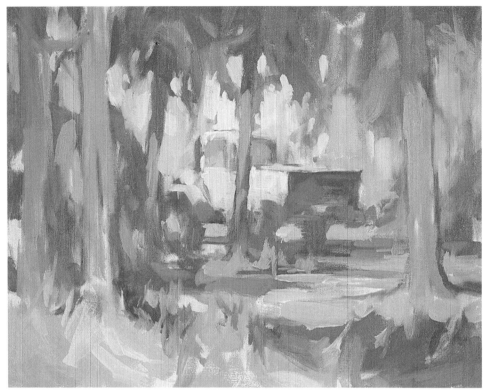

Stage III The red and orange families are now added. This reduces the predominance of yellow and green in the color harmony but still enhances the brilliance of yellow-green in the overall light effect. A cooler, lighter yellow is put into the background to show more distance and to bring the trees forward. More attention is given to controlling edges for correct form building in the trees and truck.

Step 9 Cooler reds by the tree in the lower right help to bring the yellow-greens forward. Painting the lighter red on both sides of the tree achieves more depth.

Step 10 A light yellow is painted above the truck in the background. This helps separate the truck and trees from the background and defines more of the tree's form.

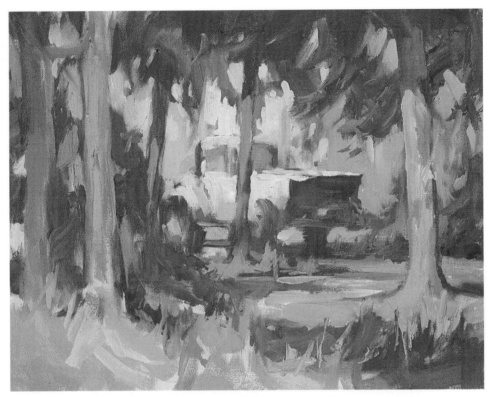

Stage IV Lighter but cooler colors have been painted over some of the warmer passages to gray them down a little. Some was done with a painting knife for brilliant color. More form is developed in the trees by introducing lighter and darker colors for definite edges. A little more detail is put into the truck and foreground grass.

Detail The tree trunk was first painted with a warmer color using a brush and a little painting medium. As the brushstroke is made, keep in mind the shape of the tree and where light areas and shadows are.

Detail With a painting knife, some lighter, cooler greens are applied directly over the warmer color. This partial mingling of opposite colors gives a brilliance to the resulting color mixture.

Step 11A When oil paint is applied with a painting knife, the painted surface has a much smoother surface than a brush gives. Edges have a tendency to be sharply defined. The color is more brilliant and crisp looking because of this smoother surface. In this section of the tree foliage, a warm olive green is worked in with bold knife strokes. Individual clusters of leaves are suggested by the knife strokes. Make your knife strokes in several different directions for interest and variety of suggested form.

Step 11B Several colors can be picked up from the palette at the same time. In this way, colors are mixed together as the knife stroke is made. As shown here, you can see where the cooler shadow on the tree trunk creates a temperature contrast to the newly applied warmer dark colors of the tree's foliage.

Step 12 This picture shows a brush being used to paint some lighter blue color in the previously painted darks in the trees in order to construct foliage form. The brushstroke is made directly into parts of the wet knife work. By leaving the brushstroke alone, definite edges of certain forms in the foliage are made. If color applied with a knife builds up too thickly, just scrape off the excess color with the knife before brushing in other colors.

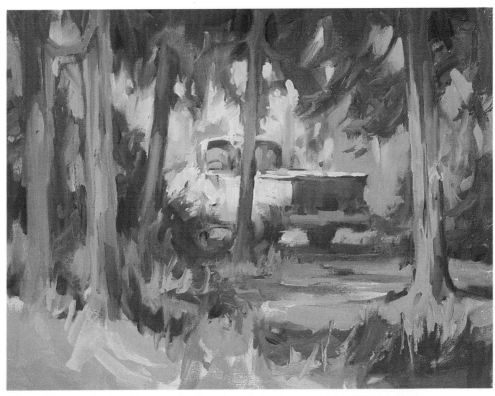

Stage V More detail and form are developed as other colors are added. When a color is painted into an area, a certain amount of drawing and form building takes place. Just bringing a new background color against something in front of it begins to define that object's form. At this stage of the painting, much of the color is applied with a knife. So the characteristics of knife work begin to influence the appearance of the painting.

Detail A light red is worked directly into a light bluish color in the truck using the broad flat side of the knife. This helps to separate the tree in front of it.

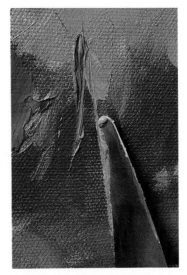

Detail Using only the blade's edge, thin lines of color are laid in. Make sure enough color is picked up, then tilt the blade on its edge. Pull and push the knife up and down with light pressure to achieve a series of sharp and thin lines.

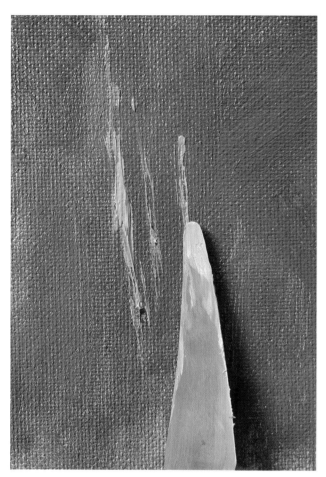

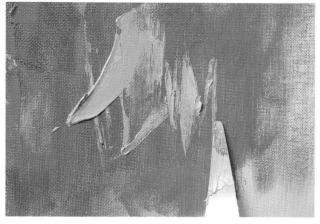

Step 13 By holding the painting knife tilted on its side, narrow strokes of color can be made. Slide the knife up and down while varying the blade's tilt for different widths of knife strokes. This can suggest narrow grass forms as well as narrow tree branches and foliage. Change direction in some of your strokes to add interest and variety.

Detail The foreground section in the lower left was painted with a brush and a knife. The stroking action described above was used with the knife. This detailed section shows the importance of the darker tonal areas and how they help to construct form with a variety of different edges. Even in this smaller section, the unity of the underlying dark and light arrangement is evident.

Detail In this detailed section of the trees, brushstrokes were combined with knife strokes in building up form. Some of the lighter blue-green in the background was brushed directly over darker knife work along the edges. This helped develop form in the tree's foliage.

Note the variety of color in the darker knife painting. You can see the canvas's surface coming through in some dark areas that were scraped to lift off excess pigment early in the painting. If heavy pressure is used with a knife, scraping can lighten a darker area considerably.

The completed painting shows how brush and knife were used together to develop this painting's idea. In some places, color was first applied with a brush and then changed slightly by using a knife directly over it. In other areas, either a brush or knife was used independently to develop form. Compare this finished stage to the first tonal stage on page 61 and see how the first idea was kept intact throughout the painting. The beginning idea for a painting and its tonal construction are the nucleus that will carry it to a successful completion. However paint is applied, whether with a brush or knife, a painting will not work without this first good beginning.

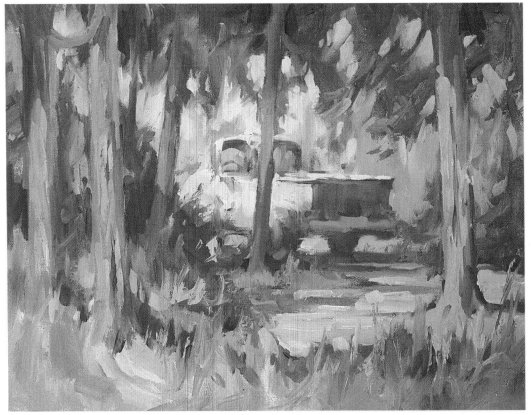

Truck in the Woods, 1991, 14″×18″

Detail This close-up shows the variety of paint handling used in this painting. Notice the importance of edges and how their contrast balances out their closeness. This picture also shows how the darks hold together and give unity to the picture arrangement. Even though yellow-greens are a dominant influence in the color harmony, this detail picture shows the influence of other colors. Try to identify how many different color families are in this picture.

Project Painting Techniques

In this chapter we covered the two basic ways of applying paint: using a brush and using a painting knife. This chapter's project concerns doing practice studies with both methods of painting. Remember, you will learn the most if you do your project studies directly from life whenever possible. It is only then that you have a true reference against which you can check your work. Use simply arranged subjects for these studies; avoid the complex and the involved. Work at your own speed and refer constantly to the preceding chapters for more guidance.

Project: Start with a basic tonal painting in one neutral color. If you want, get someone to sit for you. Otherwise, set up a simple still life. Remember to have only one main light source on your subject in order to see a good dark and light tonal arrangement. Do a painting with a brush and then try the same painting using a painting knife.

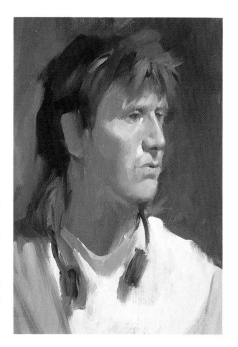

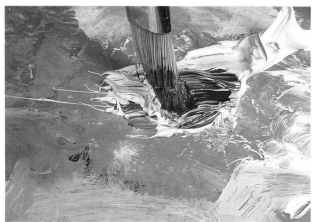

You can practice brush use and the mixing and mingling of colors directly on your palette. You can even do little thumbnail brush and knife picture studies on the palette. Don't forget to wipe off your brush or knife frequently for clean color studies.

Project: Do a landscape just using brushes. If possible, work from life or some sketches made from direct study of your subject. Don't just copy a photograph. Use dark and light values for a good subject arrangement. (See chapter 2.) Use a simple dominant color harmony. In this painting violet is the dominant color. The warmer yellow orange in the trees acts as a balance against all the violet colors. If you squint, you can see the dark and light tonal arrangement.

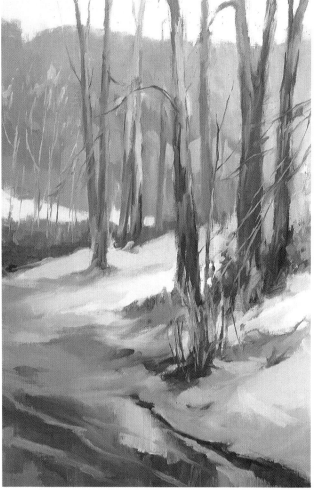

Detail of **Winter Woods**, 1989, 20″ × 24″

Project: Do a color study using a brush and knife together as explained in this chapter. For this study of some grass, I used cadmium yellow light, yellow ochre, terra rosa, cobalt blue and viridian. You don't need many colors if you choose them carefully. Make your brush and knife strokes as if you were modeling form. Mingle your colors.

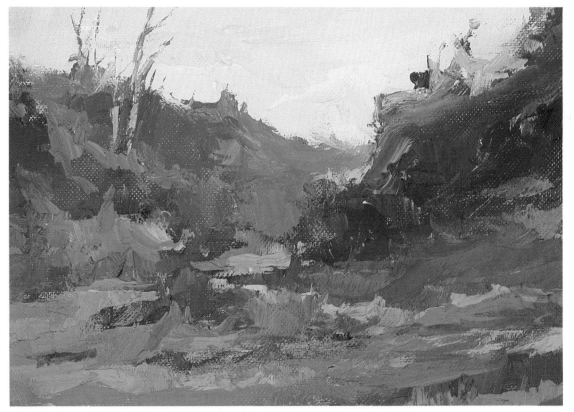

Project: Now try a painting using only a painting knife. Choose a simple subject for better control. Have a good dark and light tonal arrangement. At the beginning, sketch in the main proportions and dark and light values with a brush. Using a painting knife, apply your colors boldly but not haphazardly. As paint begins to build up, it can be scraped down and still leave some color behind. In these painting knife studies, try to keep the form from becoming too detailed. Go for the larger simple masses of tone and color. Paint studies often and work on smaller sizes, such as 9 × 12 inches or 12 × 16 inches.

Chapter Five

Step-by-Step Painting Procedure

Although there are many different ways to start a painting, only a line and mass approach gives controlled picture development with immediate results. Every good painting has a strong foundation of line and tonal mass. Line, whether it represents a boundary between different elements or a first indication of form, is probably the most natural way of starting a drawing. Using tonal mass, or the grouping together of similar values, is another basic way to build up a solid-looking painting. Therefore, a painting procedure that uses these two fundamental methods of painting is an excellent way to begin.

In the basic line and mass approach, simple line divisions and important edges of the subject are first sketched in with thinned paint. Sometimes these lines represent actual boundaries of something such as a form's outer edge or the division of light and shadow on its surface. At other times, a line may indicate movement or the direction that several different things are following. Prominent darks and the larger masses or grouping together of tonal values are then put in. At this stage, the painting is ready for the first application of color.

The second painting method is to begin directly with tone or value. In a tonal approach, a middle-value tone is first applied over the painting's entire surface to help the painter more easily judge the many different values that will make up the finished painting. Some basic lines are put in to indicate stronger darks and important edges. Deeper darks are put in and light areas are rubbed out of the middle tone. Colors are then built up on this full tone underpainting for a controlled development of the painting.

Remember, all color depends on good value relationships. If its dark and light values are wrong, a color will never look right. Using a line and tonal mass together to start a painting gives an artist a solid foundation on which to build and develop good color.

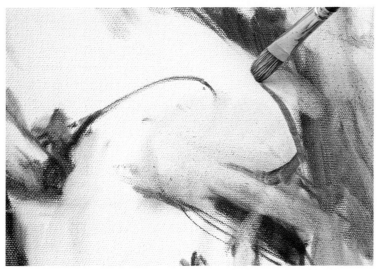

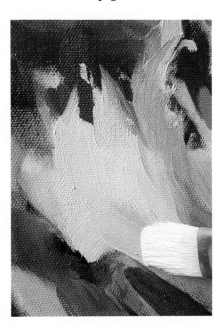

The picture above shows a small brush with some thinned-out paint being used to indicate an edge to a dark mass. A rag was used to lift out some of the light areas. The picture to the right shows bold color brushed directly over a tonal foundation. A color will only look good if its tonal value is correct. Building a painting with line and mass will help the artist later to develop good color.

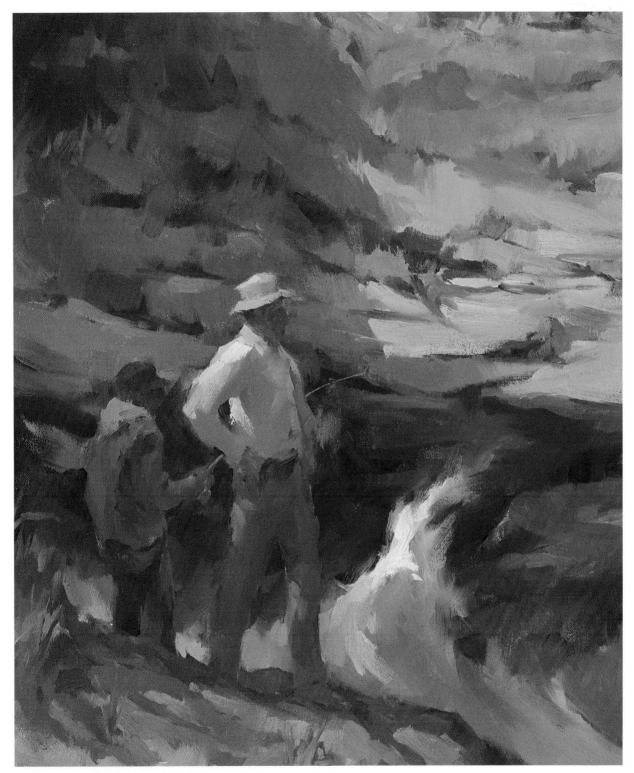

Fishermen on Rocks, 1990, 20″ × 24″

This finished painting is constructed on a strong dark and light tonal foundation. Although it represents a sunny afternoon, the dark masses dominate its composition. These darks give this subject a strong solid feeling, almost like the mass of rocks against the water's edge. There is good eye movement throughout the picture. Your eye is led into the picture from the foreground and then into the rocks and background foliage. Eye movement depends on clear line directions from edges and form arrangement.

On the following pages, I use a similar but different composition in a detailed demonstration to show the use of line and mass in building up a painting.

Starting With Line and Mass

The first lines put on an empty canvas begin to divide its proportions and surface into different picture areas. Not only do these lines block in different forms but they also suggest movement and direction in the picture. A small bristle brush was used to start indicating this line work. Some terra rosa, alizarin crimson and ultramarine blue were partially mixed and thinned with a painting medium to make the paint flow easily. At this drawing stage, select colors that will be compatible with the picture's color harmony. The complete color palette used in this painting demonstration is cadmium yellow light, yellow ochre, terra rosa, cadmium red light, alizarin crimson, cobalt blue and ultramarine blue deep.

Step 1 The first line drawing should only indicate the important things and not get into too much detail. When drawing human figures, first think of correct proportion and action as shown above and below.

74

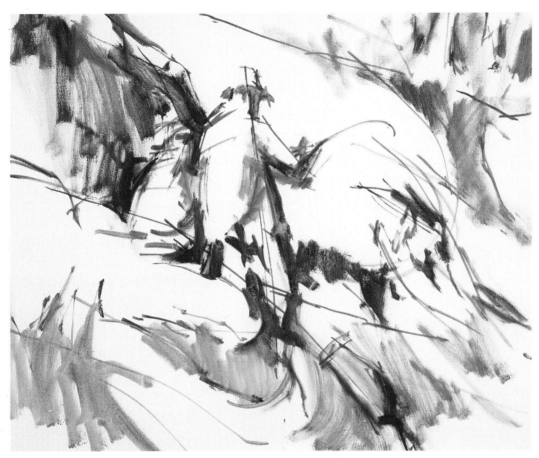

Step 2 After a correct but simple line drawing add some bold darks. This gives the drawing strength and begins to show the tonal arrangement. At this stage, it is very easy to wipe out errors with a rag.

Detail Here more darks are added, this time mixed with medium. Paint in the first darks boldly, always guided by the line drawing. Avoid putting in excessive detail; think only of larger masses of tone.

Detail Notice how these first darks show the form of the figure and indicate a light source. The first lines still influence form and action. Compare this stage of the drawing with the one shown on page 74.

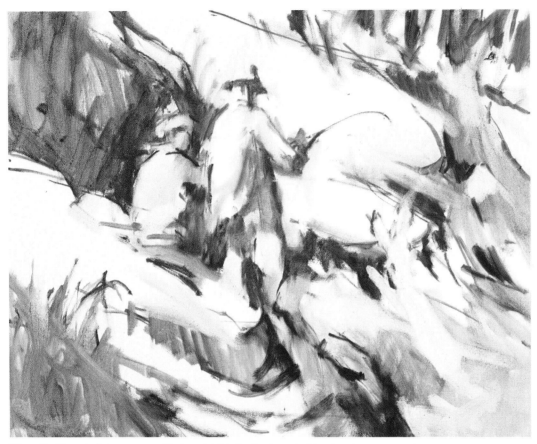

Step 3 More dark tones are put in to establish the basic underlying tonal arrangement that will be followed. A rag dampened in paint thinner was used to wipe out some of the lighter areas. When wiping out, some softening of edges will naturally take place. This suggests the modeling of form. It may be necessary to establish some of the important edges again. A little more detail can be introduced now, but avoid a too-finished look to this beginning stage.

Detail If the wiping rag is folded and shaped for better control, then more accuracy can be achieved in drawing some of the figures and other important forms.

Detail Using a rag to clean out light areas and a brush to put in important edges is a controlled way of developing a finished appearance to this first drawing stage.

Step 4 The painting is now ready for some of the base colors. These colors serve as a foundation for future color development. It is important to decide on a color harmony now if one is not already known. Several small color thumbnail sketches can be done to see which one will work best. Since this subject has a sunny afternoon light, a light, warm color was selected for the rocks. This first color is only a base color and is brushed on freely to cover the underlying tonal area with a similar value. Some of the slightly darker and richer middle tones are brushed against the first lighter color, suggesting some modeling. A little painting medium is used with these colors to make them brush out easily.

Step 5 In a line and mass approach to painting, the darks and middle tones put in during the initial drawing act as an excellent guide to finding correct colors in the lights. Therefore, the lighter areas and also some of the middle tones are painted in with base colors that can easily be developed later. Yellow ochre, terra rosa and white were used to mix the base colors for the rocks.

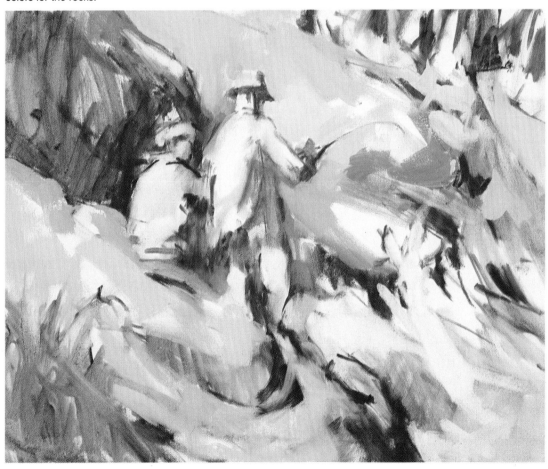

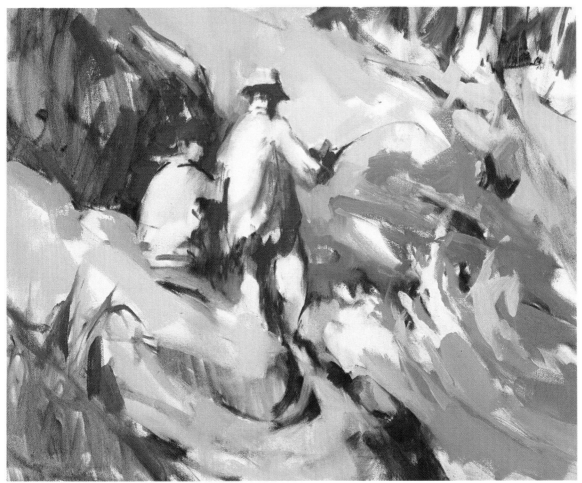

Step 6 A wider range of colors is painted into the picture to help develop form and color harmony. A cobalt blue mixture paints the blue-greens of the water. Warm grays are painted into the rocks. A touch of red is put into the fisherman's cap as a balancing color. Notice how the first darks of the initial drawing help to support these newly introduced colors.

Detail Before the cooler colors are painted into the water, the warmer base colors of the rocks are put in boldly, guided by the line and mass drawing underneath.

Detail The first block-in for the water is mixed from cobalt blue, a little yellow ochre and white. Mix the foam from white with a little cobalt blue.

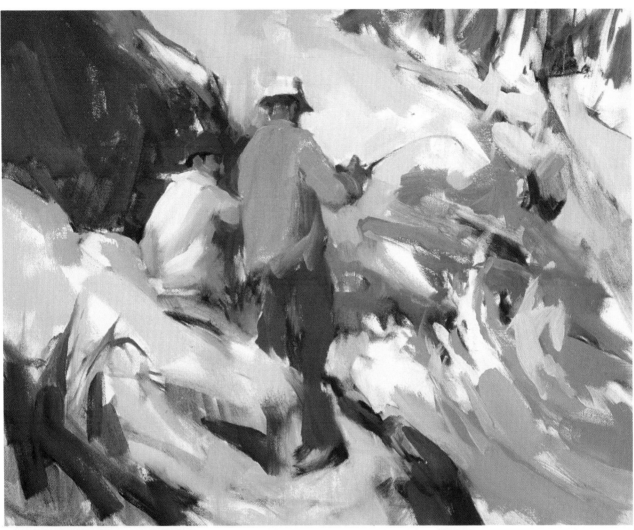

Step 7 A darker color made of terra rosa, cobalt blue with a little yellow ochre or cadmium yellow is now put into the darker areas of rocks, background and foreground. Some of the colors in the figures are brushed in to suggest more form.

Details The figures are painted by first working in some of the middle-value colors following the tonal drawing underneath. A light color is brushed over a darker color to model some of the clothing's form (*far left*). The initial drawing is followed to paint the other person's yellow jacket (*left*). Compare these pictures to see how the figures were developed.

Step 8A A lighter yellow color is added to show form in the jacket.

Step 8B The outside form of the figure is defined by painting the lighter background color against it or into it where necessary.

Step 8C A mixture of terra rosa and cobalt blue is brushed boldly against the background to find the edge of the pants.

Step 9 The base of the trees in the painting's upper right was first blocked in with a mix of terra rosa and yellow ochre (*top*). Warm darks are then brushed over this base color to develop edges and form.

Step 10 Cobalt blue with a little white was brushed into the shadow darks to give them a cooler color temperature (*top*). The warmer light color of the rocks is then brushed against the shadows, keeping edges varied.

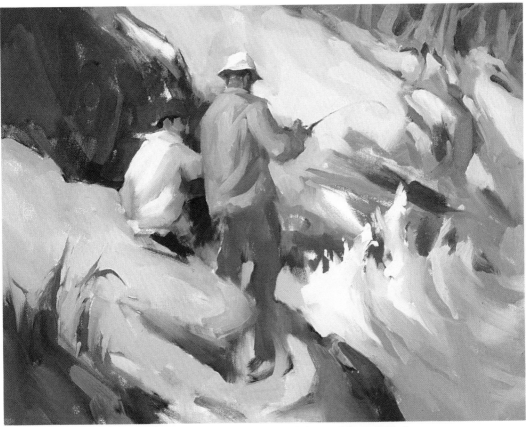

At this stage, the painting has been almost completely covered. Some of the individual forms such as the figures or water are near completion. Notice how the original block-in colors have been followed and developed.

Details Warmer colors are freely brushed into the wet cool shadows for a partial mingling of colors (*far left*). A few well-placed darks help to bring out the figures. Brushstrokes like those at left actually draw form while they paint color.

Step 11A A few well-placed strokes of a lighter blue help build a foundation color in the water for later finishing.

Step 11B A light color is brushed in with a large flat brush and carried across some of the dark rocks to show water spray.

Step 11C Other light colors are brushed across some of the darker water colors to show the water's surface.

Step 12A A small flat brush was used to indicate some of the basic forms of the grassy area in the painting's lower left. The color used is mixed from terra rosa and cobalt blue with a little cadmium yellow.

Step 12B Definite narrow strokes made of a lighter green were brushed across the dark warmer color to show some of the grass. Leave these strokes alone to achieve a fresh appearance in the painting.

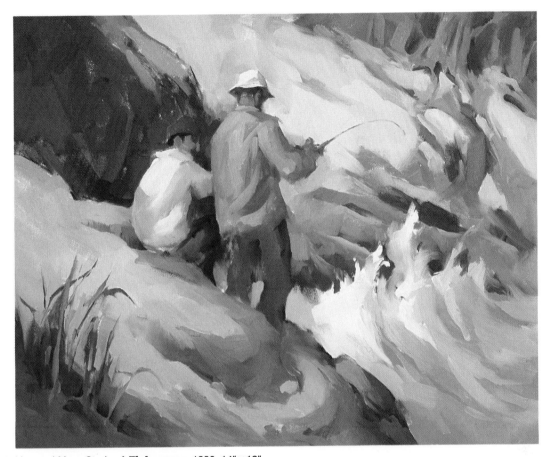

Line and Mass Study of **Fishermen**, 1990, 14″ × 18″

The finished painting shows how all the colors and forms were developed to completion. Compare this stage to some of the earlier ones to see how the original tonal pattern was followed throughout the painting's development. Look at the movement in this painting and see how the original line drawing established it at the very beginning. A line and mass approach to painting can put in much of the finished effect at an early stage.

Detail Some of the final modeling of form in the rocks was done by overpainting the darker cool color underneath with a lighter warm color using a wide flat brush.

Detail Subtle color changes in the water were achieved with deliberate strokes directly over the underlying color. Notice how the variety of edges adds interest.

Starting With Tone

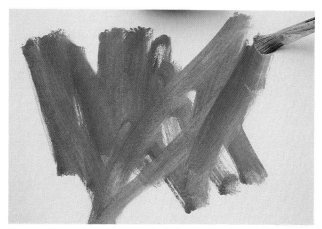

Step 1 Terra rosa, yellow ochre and a little cobalt blue with some painting medium is brushed over the surface.

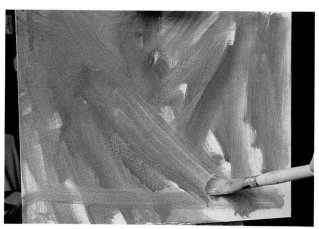

Step 2 The thinned-out color is brushed over the entire surface. Neatness or even application of color is not important yet.

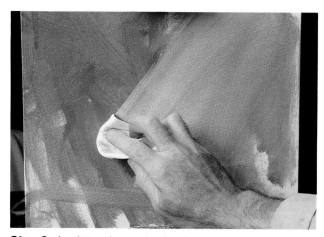

Step 3 A paint rag is used to wipe down the painting's surface. Use firm but even pressure in several different directions.

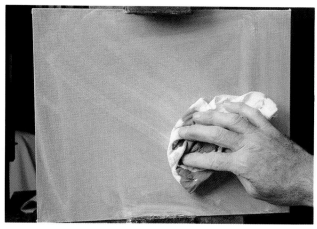

Step 4 As an even and lighter tone develops, lighter pressure is used to keep from taking off too much tone. It is semidry.

Step 5 A small filbert brush was used to start the first linear strokes. These lines divide the picture area into its main parts.

Step 6 Some deeper darks were added. The middle-toned surface makes it easier to see all the value relationships.

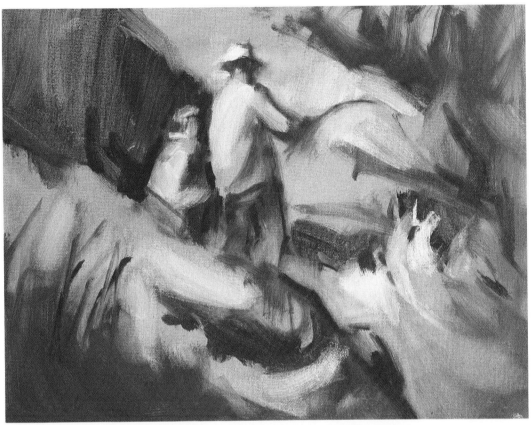

Stage I Starting a painting with tone gives an immediate tonal preview of the finished work. The light effect, subject arrangement and composition can be judged easily. Since correct values are an important aspect of good color choice, starting with tone also helps to find the right colors.

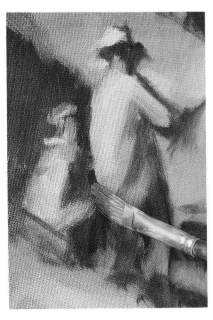

Details *Far left.* A paint rag, folded to give more control, is used to wipe out some of the lighter areas. It is dampened with thinner so it cleans out the lights more fully. *Left.* After wiping out the lighter areas, some stronger edges were put in using a brush and the original toning color.

Step 7 The tonal drawing was developed by wiping out areas with a rag. If the rag is folded right, even small details can be lifted.

Step 8 After wiping out the lights, some edges may be softened and lost. Put them back in with well-defined brushstrokes.

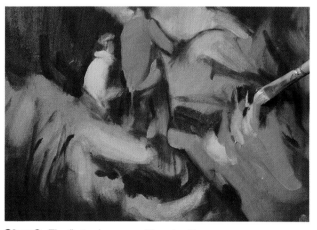

Step 9 The first colors are put in using the tonal drawing for guidance. Colors are mixed on the palette, checking for value.

Step 10 A touch of red was brushed into the fisherman's cap for balance. The bold yellow was guided by the tonal drawing.

Step 11 Warmer colors were brushed into the rocks. The darks in the tonal drawing help in judging the lighter colors.

Step 12 Some cooler colors were brushed into the warmer darks, though some of the original color can be kept.

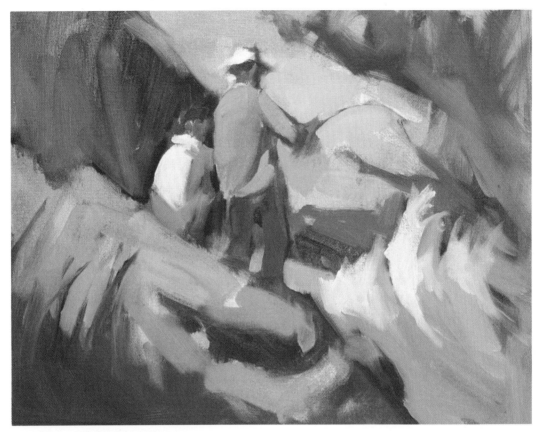

Tonal Study of *Fishermen*, 1991, 14″ × 18″

When using a tonal approach, only a few basic colors are necessary to bring the whole painting together. Again, make sure that the first toning color is compatible with and part of the final color harmony. This is an excellent approach to use when painting landscapes outdoors where the changing light calls for a rapid approach to painting.

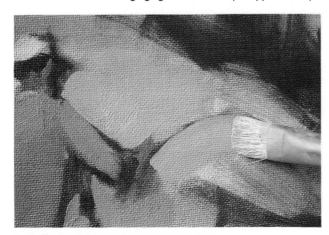

Detail The lighter background color of the rocks is brushed in. The figure is shaped by brushing the lighter background color up against it. Some of the original tonal darks are kept as part of the figure's form.

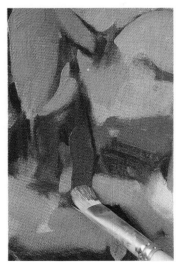

Detail Using a warm dark color, a well-placed brushstroke gives more form to the man's leg. Notice how the lighter blue water behind the leg helps to bring it forward.

Project Step-by-Step Painting Procedure

Project: The first project will be a practice painting using the basic line and mass approach. Select a simple subject from life or your imagination. (Refer to chapter 2 for help in developing your ideas.) Lay out a solid line and mass drawing, then begin to block in some of the basic colors directly over this first stage. Try working with several different subjects and arrangements. This is only a practice study, so detail and finish are not important. Make several studies, keeping them under 12″ × 16″ in size and using simple color harmonies.

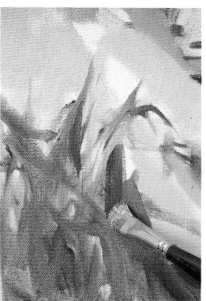

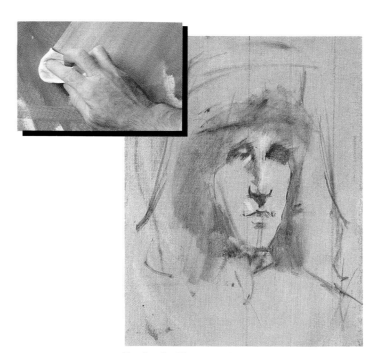

Project: The second project is to use the tonal approach for a practice study. Wipe an even tone on your canvas or panel. Lay out the first lines and tonal shapes. Work from life if possible, doing a simple portrait, still life or landscape.

Develop the drawing with correct edges and tonal masses. Wipe out the lights with a paint rag. When studying your subject for dark and light values, remember to squint. Keep these studies simple and only at a block-in stage.

Project: For practice on a simple everyday subject, try working in your garden or backyard at different times of the day. Pick out some quiet corner with a good dark and light arrangement. Use the line and mass or tonal approach to get started. At this time, don't worry about finishing, just strive to achieve a good beginning and block-in of color.

I started this tonal painting with a good line and mass drawing that was applied directly on a toned surface. Five values were premixed on the palette from ivory black, burnt sienna and white. These different values were then painted directly on the first line and mass drawing using a painting knife.

This 11″ × 14″ knife study was painted directly from life in the corner of an ordinary garden. I used the tonal approach because it was necessary to establish the sunlight and shadow pattern early. My colors were boldly applied with a painting knife to achieve the effect of light that I wanted.

Corner of the Garden, 1979, 11″ × 14″

Chapter Six

Pulling It All Together

Learning to mix color and apply it with a brush or knife is just part of the whole painting process. There are many different things that go into making a painting. Some of these are tangible things like line, tone, color and technique. These can be studied individually, and skill can be achieved in using them separately. However, it is only in the combining of all these important parts that actual painting becomes possible.

When a painter is working, all these separate skills should be available for immediate use without any hesitation or doubt. The creative process is something unique to each individual true artist. Each one works in his own way, taking an idea and developing it the way that only he sees it.

An important part of the pulling together process in painting is developing a personal sense of balance and feeling in using all these different things. Although line, tone, color and technique are important building blocks in painting, the glue that holds it all together is the artist's personal sense of balance and feeling.

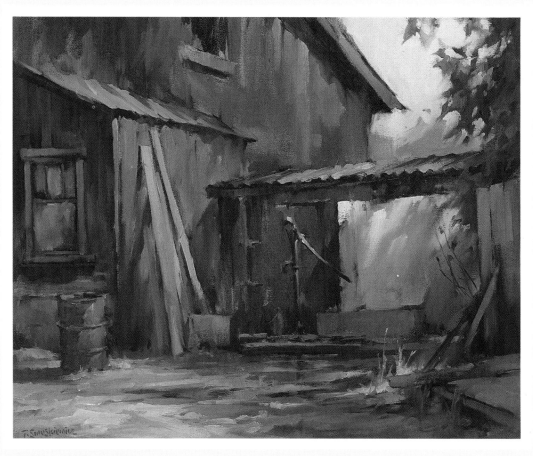

Farmyard With Pump, 1990, 16″ × 20″

Pictorial Balance

When we look at something, we see it our own individual way. Dark and light tonal arrangements and the juxtaposition of different colors are important pictorial influences immediately noticed by an artist. Even the edges or boundaries that separate some of these different areas will affect the way a subject appears. An artist looks at something and takes it all in. He or she then begins to balance and compare these different things against each other.

Personal feelings come into play at this time and strongly influence the way someone will use tonal arrangements or color. Its final use always depends on what we as individual artists make of it.

As we have seen in chapters 2 and 3, certain balances and ways of using tone and color give pleasing results. These sound ideas should never be ignored. However, it is also important, as one becomes more involved in painting, to be ready to temper and adjust these basic ideas of tone and color use to reflect a personal feeling and way of seeing a subject.

The dark and light tonal balance is perhaps the strongest factor affecting the way a painting appears. In my painting, *Farmyard With Pump*, shown on the opposite page, late afternoon shadows create a pattern of dark and light. This dark and light pattern is shown here in its simplified form. Notice how the darks dominate the picture area and how they all connect together. This gives a more solid appearance to the picture. It was entirely up to me to decide how much the darks should dominate and where the connections between the different dark areas should be. Personal ways of seeing and feeling about a subject are always the first important control used in putting a picture together.

In this painting detail two important pictorial balances are evident. One is the way bright intense colors are complemented and supported by larger areas of gray colors. This reverse ratio between intense and gray colors is a basic color balance principle covered in chapter 3. The other pictorial balance involves the way different edges are used against each other. Harder edges are complemented by softer edges. Some edges are extremely sharp, while others are very soft and almost lost. A basic and important idea of balance is in the way opposites are used together.

Detail of **Farmyard With Pump**

Using Line and Mass for Unity

Every good painting has to hold together. Something has to keep all the different elements working together to show what the artist wanted to depict. This is accomplished by line and mass. Both share their influence on a painting to give it unity and hold it together.

One simple but important effect of line is how it gives borders or edges to forms, enclosing them and defining what the forms are made of. Another important function of line is to give direction and lead the viewer through a picture. Sometimes lines are strong divisions between different tonal and color areas. At other times, linear edges of several individual forms can combine to form a single strong line. This line not only helps carry the viewer's glance along it but it can also hold together a picture's many disparate parts.

Mass is the other important pictorial influence that gives unity. Mass can combine many different objects that are similar in tonal value or color into one unit. It is the natural result of mass to unify. Anytime several things are similar in a picture, especially tonal values, there will be a pulling together of these things. Using mass correctly in a painting is a dependable way to achieve unity. Another important advantage to painting with masses is that it makes beginning a painting much easier, as clearly demonstrated in chapter 5. A painting is easier to finish successfully if it is always kept under control. Using both line and mass will help accomplish this.

Lines can give unity to a painting. This analytical diagram shows how simple but strong unifying lines are formed in the painting. Besides leading the viewer's glance with their directions, a few main lines also enclose many of the individual forms. For instance, notice how the standing figure in the doorway is combined with a larger shadow mass by some definite lines or edges.

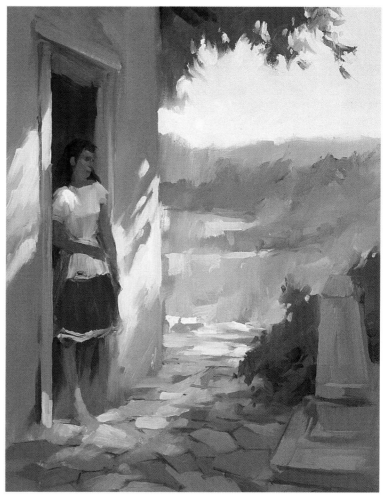

Girl in a Doorway, 1991, 16″ × 20″

This painting uses both line and mass as an important part of its construction. The standing figure is the central idea or interest although it is placed well to one side. Darker masses of tone, strong edges and the bright red help direct the viewer's eye first toward the figure. However, from there, the bright sunlight on the wall directs the viewer to the rest of the painting where he can explore the painting fully.

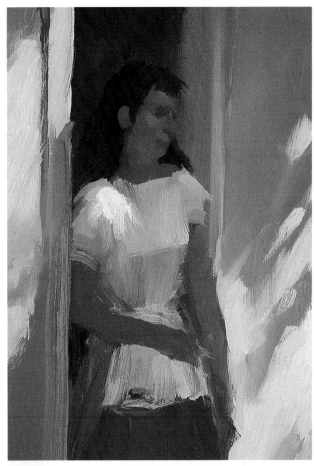

The idea of line and mass is clearly shown in this detail of foliage. The sky and foliage meet along an uneven edge that is actually a diagonal line. This line distinguishes the two masses, foliage and sky, as separate units yet holds them together because they share the same border. Notice how your eye is led along this border or edge. Its uneven edge keeps your glance from traveling along it too quickly.

The detail of the figure in the doorway shows the holding-together power of a mass. Sunlight on the wall creates edges that form a solid mass of shadow. This shadow mass holds the figure and wall together as one unit even though the figure and wall are several different surfaces and colors.

This is a simple mass arrangement of tone and color. A diagonal line or edge separates the warmer sunlit area from the cooler shadows. In some places there is much contrast between them, while other places show little difference. The paving stones help make a bridge between shadow and light by providing middle-tone areas as a connection. This detail picture shows a diagonal division of masses that is similar to but not as strong as the sky and foliage picture.

Dividing the Picture Rectangle With Lines

Everything that is placed within the enclosing borders of the picture rectangle relates in some way to everything else that is already there. This arrangement is part of composition. To make separate and different things relate, some attribute must be shared between all of them. Sometimes different parts of a picture relate together because they share the same tonal value or they may be very similar in color and hold together only because of color.

There is another way to group or hold together different aspects of a picture. If, at the beginning of a painting, some straight lines or divisions are randomly drawn across the picture rectangle in different directions, a guide is established to place things against. Parts or edges of different forms throughout the picture are placed on the same straight line. They relate to each other because they all are connected in some way to the same line. Whenever several different things in a picture share a common relationship, unity and control are established. Using rectangular line divisions helps to achieve this.

The dark shapes in the top picture are too evenly spaced in their placement, resulting in a static arrangement. The bottom picture shows the same shapes placed along two linear divisions with some of them touching the lines. This new arrangement is more interesting because of the line relationships and uneven spacing.

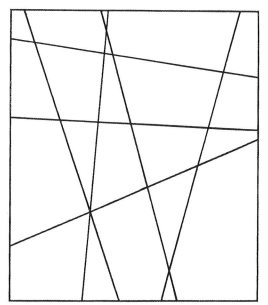

Step 1 A picture rectangle is divided with a series of randomly placed straight lines. Several of the lines intersect in the same place. The resulting areas are uneven in size. Remember the principle of uneven sizes and divisions for good balance as covered in chapter 2.

Step 2 Holding together a subject's various forms within the picture rectangle becomes easier with uneven linear picture divisions to guide you. Several different forms or parts of a form are positioned on the same line. Notice how the head of the standing figure in the upper-left background aligns with the man's chair in the foreground by sharing the same line.

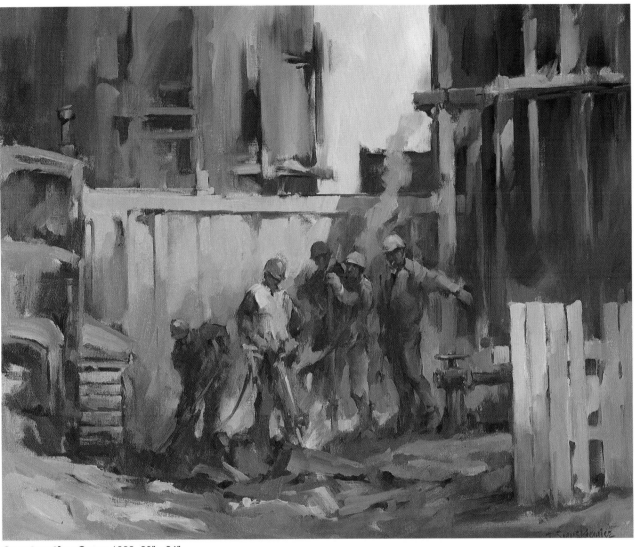

Construction Crew, 1988, 20″ × 24″

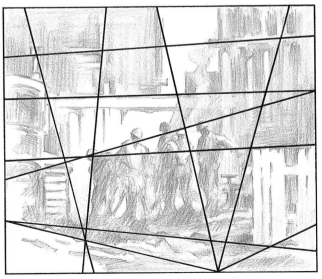

Line divisions are used in this painting to help align its many different parts. Not only do the line divisions make placement of individual forms easier, but they also help in the arrangement of dark and light masses.

Some lines describe a strong linear edge in the painting. The light-colored fence in back of the standing figures follows such a horizontal line at its top. The shorter fence in the right foreground also follows a line for its top edge but not as closely. Look how many different things in this painting share the same line. If too many forms and edges follow these line divisions very closely, then the painting can take on a definite linear appearance. In some places I planned that this painting would do just that.

What Makes These Paintings Work?

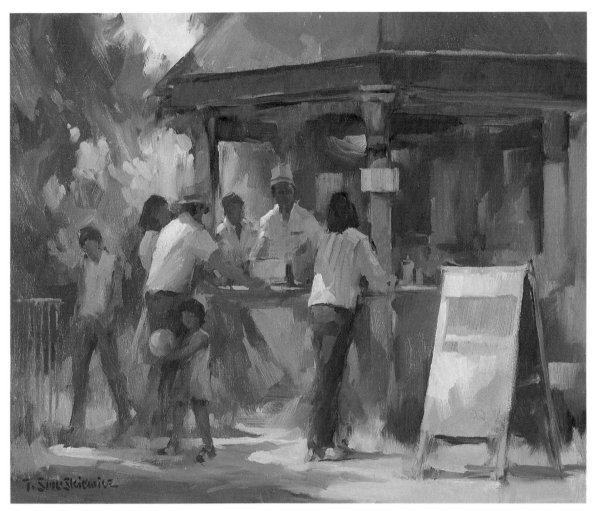

The Vending Stand, 1990, 8″ × 10″

This painting is built on a strong dark and light tonal arrangement. It was started with a line and mass approach, so tonal values were established early. The unifying influence of the dark masses was considered from the very beginning in the placement of all the individual forms. Although there are many figures, they all are grouped together, each one touching or overlapping another. Dark masses are part of the figure group and contribute to holding it together. The smaller spots of light striking the shirt add interest to an otherwise similar area. Some places are very busy with much detail, while other areas provide a good balance by having little detail and not much change in tone. Bright intense colors are balanced against larger gray areas. Above all, this painting has a definite light effect that contributes much to the overall feeling.

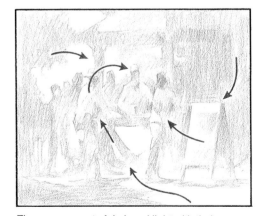

The arrangement of dark and light with their contrasting edges helps to lead the viewer's glance through the painting. The viewer is led into the picture along a strong shadow division in the foreground and then into the figures and background.

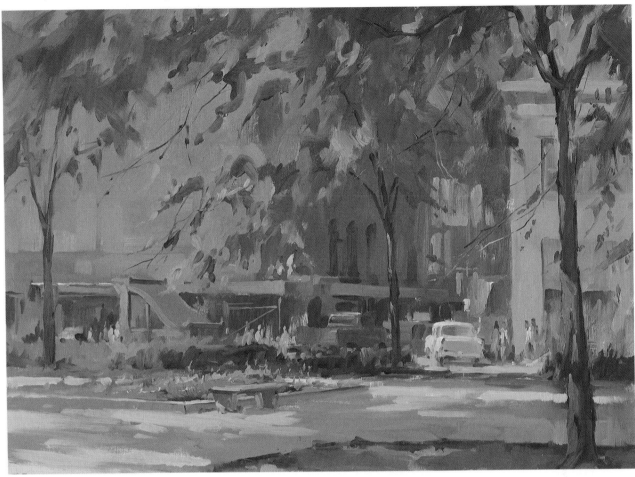

From Grant Park, 1988, 12″ × 16″

Squint at this painting and you will see the underlying arrangement of dark values that holds together as a pattern. Although there are many different colors present, they all relate to either the dark or light masses. The dark masses dominate in this picture and give contrast to the smaller light areas. This enhances the overall sunny effect by using light and shadow together. Smaller areas of intense colors are balanced by larger areas of quieter gray colors.

Notice how the viewer's glance is led into this picture through the foreground along divisions between light and dark. The dark edge along the foreground grass and bench helps direct the eye toward the light car in the lower-right background. The car then pulls the viewer's glance into the background along the street in shadow. By using edges of contrasting value and strong lines, the artist can lead and direct a viewer anywhere in a painting.

The underlying dark and light tonal arrangement is the foundation for all color and form development in a painting.

For effective color, smaller areas of intense colors are balanced against larger areas of neutrals and grays.

Values and Edges

What we call "modeling of form" is really the result of dark and light values coming together in a particular way. Every surface is different and therefore receives light in a different way. For instance, the girl's hand has its own surface form that reveals itself in a certain way in this type of light. Her apron and sleeve will appear differently. In order for the values of light and shadow to be consistent there should be only one main light source. If the light is warm and coming from the right, then whatever the surfaces are, they still will be illuminated by a warm light coming from the right side.

When light creates shadows, it also creates different types of edges. In the girl's apron there is an arrangement of hard and soft edges because of the curved surfaces and cast shadows in the fabric's folds. This gives interest besides helping to show form. For good form representation, all edges should not be the same.

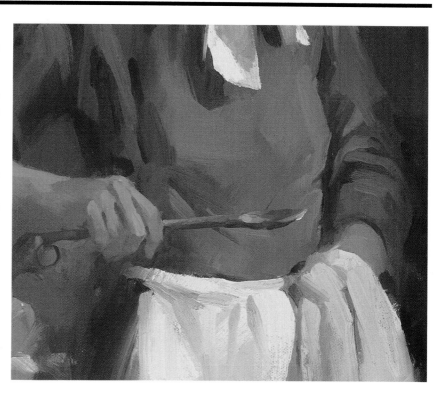

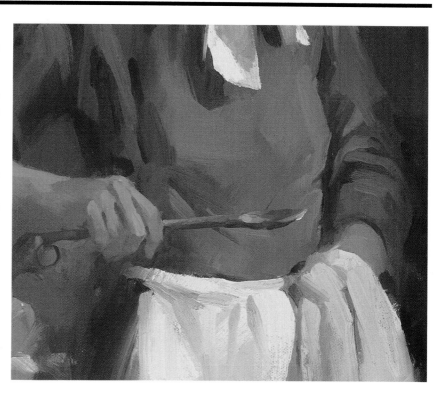

Color Harmony and Balance

If a light is well saturated with a certain color, its dominance becomes the reason for using a certain color harmony. Local colors begin to lose their own identity in a strongly colored light.

As we know, every good color harmony is balanced with opposite colors and gray colors. Dark and light tonal arrangements can also act as a balance between different colors. For instance, the lighter and warmer face color receives part of its brightness from the darker and cooler shadows on the side of the head.

Painting Technique

A tonal approach was used to start this painting because of its overall dark appearance. Strong edges were indicated to distinguish light from shadow and thus enhance the tonal pattern. Paint was put on basically with a brush and freely worked into the tonal drawing. Knowing the right painting approach and its technique is an important part of achieving the correct effect in a painting.

In this costumed, period painting, special lighting was arranged on the model to give the painting its overall effect. I used a spotlight with a warm filter to duplicate late afternoon sunlight coming through a window. The setting is an interior, so there are lots of dark areas in the painting. Form is barely visible in the shadows. The shadows and other darks enhance the lighting effect, making it appear more intense. The warm light pushes the harmony toward red and orange. Cooler colors are present and act as a balance against the warm colors. Neutrals and grays are an important part of the color and general light effect. A strong dark and light value arrangement holds the whole picture together.

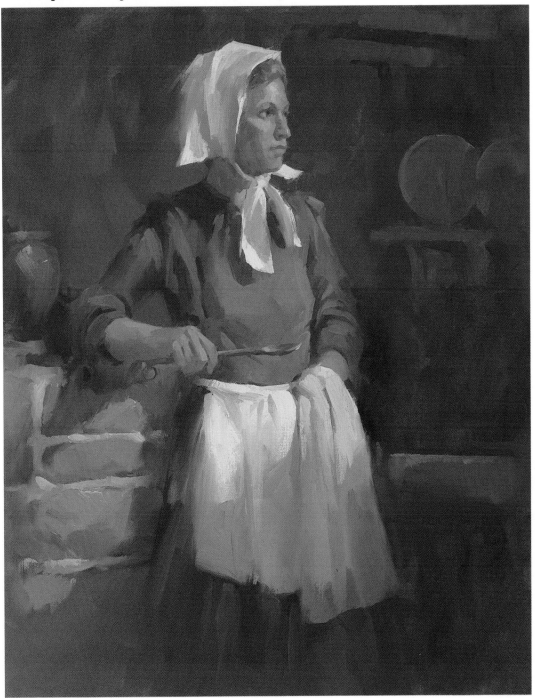

Pilgrim Girl, 1991, 16″ × 20″

Project Pulling It All Together

As a project for this chapter, try to use some of the different techniques and approaches that make a good painting by doing several studies. Line, tone, color and technique should be explored more fully by concentrating on them separately.

After you have selected a subject, compose or arrange it within the borders of a picture rectangle. Refer to chapter 2 for guidance on tonal arrangement. Don't just copy a photograph; try to put together a picture that shows your ideas about your subject. Doing smaller thumbnail studies first is an excellent way to solidify your ideas in picture form. Each different subject, because of its individual makeup, can accommodate certain distinct compositional treatments. Keep these studies simple and right to the point. Remember, getting your idea started correctly is the important thing. What is not begun cannot be finished.

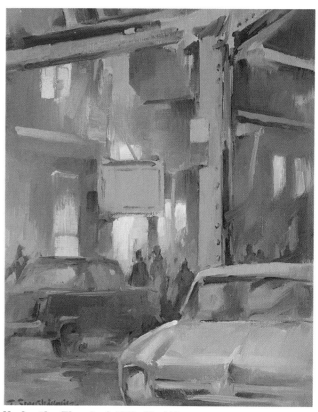

The painting to the right has strong linear influences, but it also has a clear dark and light mass arrangement. Therefore, a basic line and mass approach may be the best way to get it started. Starting with line divisions is an excellent way to determine the best placement of forms.

Project: Compose and paint a subject by first starting with linear divisions of the painting rectangle and dark and light masses.

Under the Elevated, 1989, 8″ × 10″

The enclosing picture rectangle is a very important part of pulling a picture together.

Project: Choose a subject that you just painted and arrange it in a different sized and proportioned picture rectangle. Everything doesn't have to be included in the new picture arrangement.

A Summer Field, 1991, 14″ × 18″

Strive for a good light effect in every painting. I painted this painting outdoors, directly from life. It is constructed on a strong dark and light tonal foundation. A painting knife was used to show the crisp effect of light and shadow.

Project: Try painting an outdoor study of some simply arranged subject that has a good light and dark pattern. Refer to previous chapters for help in achieving good light effects in your work.

Night paintings can yield very striking light effects. I did this painting in my studio immediately after observing it and drawing a few quick sketches with pencil. It is difficult to paint outdoors at night because of the poor light. Therefore, you must train yourself to observe and remember the important things that make a night subject look a special way.

This painting has a strong pattern of dominant darks against smaller lights.

Project: Try a subject strictly from memory. When observing, concentrate on comparing basic compositional points that you see in your subject. A tonal approach was used to begin this painting.

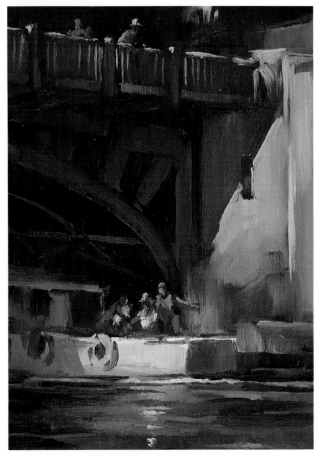

Detail of *Under the Bridge*, 1982, 11″ × 14″

Chapter Seven

Painting Landscapes

Landscapes have always been a favorite subject with artists. There is such a large variety of subjects available. And every landscape is different, not only because of the subject matter itself, but also because of the constantly changing light.

If a particular subject doesn't appear too interesting at a certain time, just wait or come back later and it will appear entirely different. This constant changing of light is continually creating new and different things to see. That is why an artist must paint directly from life and nature whenever the opportunity is present. Only life and nature give an artist so much to choose from, and therefore, learn.

Painting landscapes outdoors requires not only the technical skills of painting but also demands of the artist the ability to truly see, to recognize the large important things that will eventually come together as a

painting. It also demands you be honest with yourself and aware of your own response to or feelings about your subject.

Never have preconceived ideas about what you will find outdoors. Each day should be an adventure in finding new things to paint. Go about it with sharp eyes and an open mind, always ready to take in anything that comes your way.

Look for simplicity in your subjects but look at them differently than others do. For instance, in the painting shown below of boats tied to a dock, I was first impressed with the overall warm autumn color and the way the water looked. Finally, the red boats became important as they showed through the trees. Although they are the center of interest, the overall color and tonal arrangement of this painting sets its mood and feeling.

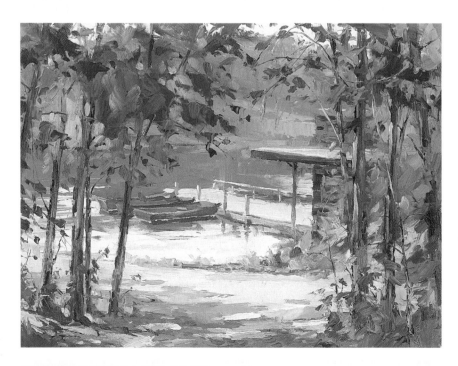

Boats Through Trees, 1980, 12″ × 16″

Outdoor Painting and Sketching

Painting and sketching outdoors doesn't require much equipment or an elaborate setup. Depending on what you are going after, you can get by with minimal equipment. The important thing is to have the right equipment that will allow you to accomplish your purpose.

The ordinary sketching-paint box is a basic piece of outdoor painting equipment. In fact, its design is so efficient that, usually, it is all you need. Make sure that you obtain a sketching-paint box that has slots in its lid for holding painting panels. There should be compartments in the lower half for holding brushes, painting knives, tubes of paint, and small containers of paint thinner and a painting medium. An arm palette fits in snugly, covering the compartments below, and is held in place when the lid is closed. When the lid is opened fully, a bracket on the side automatically locks it in an open position. The box is used as shown in the illustration. It can be supported on the knees while sitting. A belt passed through its handle and around the user's waist will help keep the box from sliding off. The palette sits in the lower part and colors are mixed directly on it. The box can also be placed on the ground or some other support like a ledge.

Painting is done directly on a panel held in the open lid, which serves as an easel. A sketching-paint box that holds 12 × 16-inch panels is a convenient size to use. If you are doing smaller studies, simply divide a 12 × 16-inch panel in half with a piece of ½-inch masking tape. This will give you two surfaces on the same panel for your painting studies. A small carrying bag for additional equipment and a folding camp stool to sit on can also be easily carried with the paint box.

If you are painting on larger panels, a folding sketching easel is necessary. There are many different kinds available. The folding tripod type is probably the most efficient for its affordable price. Make sure that the easel is soundly made and that it has spikes on the ends of all the legs for inserting into the ground. This will give it more stability. When you are using an easel outdoors, painting is generally done from the standing position while holding an arm palette. Using an arm palette allows the painter to step back easily in order to see what is being painted.

When painting outdoors, you may find that the sun can be a problem. Avoid working directly in the sun as the brightness of sunlight makes it difficult to judge colors. Position yourself so sunlight does not directly strike the painting's surface. A wide-brimmed hat is always handy as it helps shade your eyes. Sometimes outdoor painters use a large umbrella with a long pole to hold it upright for shade.

Panel Held in Paint-Box Lid

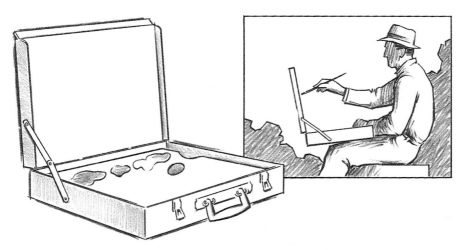

The sketching-paint box is a convenient and portable piece of outdoor painting equipment. Painting panels are held in slots in its lid, which functions as an easel when locked in the open position. A palette for mixing colors rests in the lower section, covering compartments holding brushes and paints. It all folds up into a portable case that's easy to carry.

The sketching-paint box can be used by supporting it on your knees while sitting. A belt or strap passed through its handle and around your waist will keep the box from sliding off. A portable folding camp stool makes a convenient seat. Don't forget to wear a wide-brimmed hat to shade your eyes.

Using Line and Mass for Landscape: Step-by-Step Demonstration

A good way to start a landscape painting incorporates the basic line and mass approach to painting. This is a controlled way of developing a painting that helps the artist visualize the finished effect at the very beginning. Applying an overall tone to the painting's surface before starting reduces the stark contrast of white and makes it easier to put in the darker masses.

Using line and mass in the first drawing helps to express the effect of light by showing where the light is coming from and how it builds some of the forms. The dark and light masses should be put in as soon as possible because dark shadows are an important part of a light effect.

When painting outdoors, the light is constantly changing as the day passes. It is important to start with a certain light effect and stay with it. Starting with simple masses of tone and color is a good way to get immediately into a light effect for a painting.

The following step-by-step demonstration uses a toned surface with a line and mass beginning.

Step 1 Apply an overall tone to the surface by brushing on a neutral color diluted with paint thinner and then wiping it down with a paint rag. This first tone reduces the strong contrast of working on white.

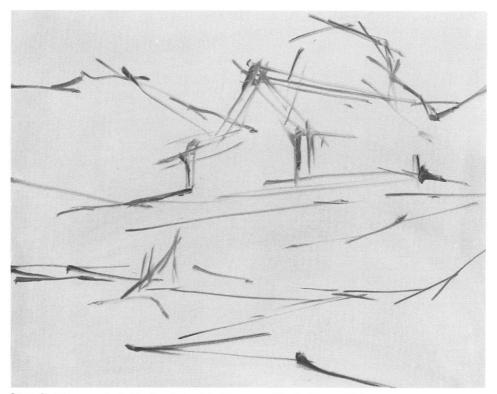

Step 2 With a smaller bristle brush, I painted in some of the first lines with terra rosa and cobalt blue diluted with a little painting medium. These colors are compatible with the finished painting. The first linear divisions of the picture area help establish placement of major forms like the trees, barn and foreground shoreline. They also begin to suggest movement and direction throughout the picture.

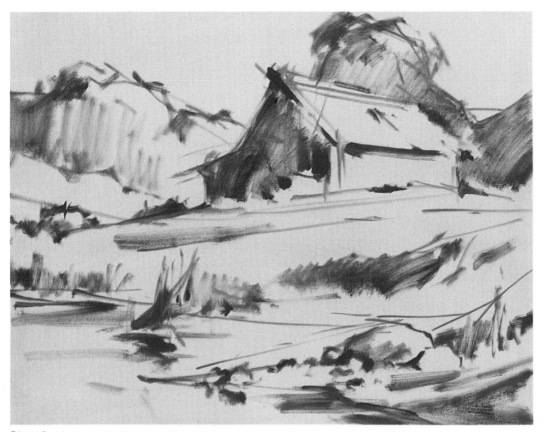

Step 3 I began to lay in some of the darker masses, keeping in mind where the light is coming from and how it affects individual forms. When painting a landscape, first try to recognize the major shapes and their direction. For instance, the vertical walls of the barn, the gently sloping but still horizontal field, and the angled flat surface of the barn's roof.

Knowing how a surface relates to a specific light direction helps you choose the correct dark masses that identify its form and shape. I kept this first stage of the painting somewhat sketchy and not detailed. Although this first drawing does suggest the finished appearance of the painting, its main purpose is to give a good foundation for color development.

Detail This view of the barn shows how I applied masses of dark tone. Notice how some of the original line drawing still shows and is influencing the placement of the dark masses. The picture's composition or arrangement is strongly affected by the way darks and lights are used. Refer to chapter 2 for some of the important uses of tone in pictorial composition.

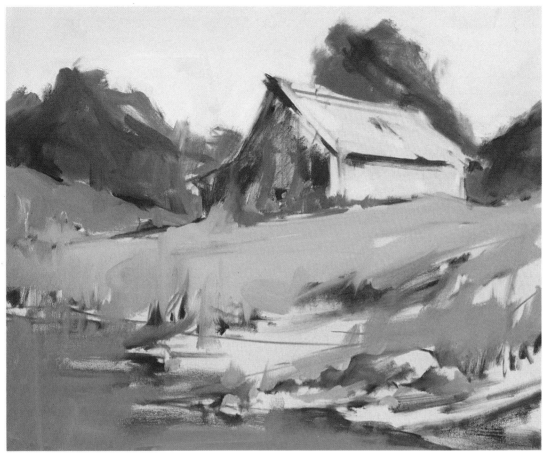

Step 4 Next I painted in some of the basic block-in colors. I used a small amount of painting medium to make the color spread out and brush easily. My color palette consisted of cadmium yellow light, yellow ochre, cadmium red light, terra rosa, alizarin crimson, viridian and cobalt blue. These first colors don't have to completely cover the surface. At this stage, they are only base colors and will later be overpainted in part.

Detail This shows how the first colors were blocked in for the barn. You can still see some of the original line and mass tonal drawing. Compare this with the previous stage to see how the starting line and mass drawing influences color in the painting. A light cool gray made of cobalt blue and white with some of the yellow-red mixtures on the palette was blocked in over the barn as a base underpainting color. It will be painted over with some warmer colors.

Lay these first colors into the painting in a flat manner, with very little modeling. They are just foundation colors for future form development.

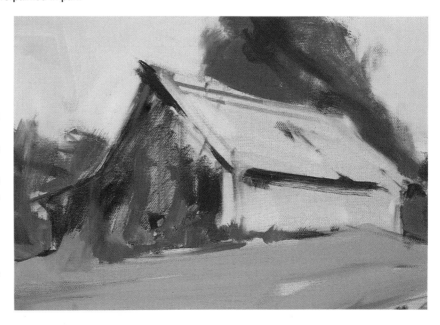

Detail On the background trees, the first red base color was blocked in freely. I painted darker cool reds in the shadow areas to help show more form and then brushed some warmer reds into the lights. The shadow darks in the trees were brushed in with cooler blues mingled right into the wet red base color. If some of the subject's form can be shown in an early stage through good tone and color use, it should be painted in at that time. Whenever an area looks close to being finished, put in whatever else is needed at that time.

Detail For the shoreline and grass, the first block-in colors were not painted in too heavily, as I planned to overpaint them later. A blue base color of cobalt blue, a little yellow ochre and white was painted in for the darker water. Some brighter and more intense blues were also mingled into the wet bluish color. The same approach is used in the grassy area behind the water but with yellow-green colors. For more variety and interest in the first base colors, brush in some other colors of a similar value.

Detail On the rocks, I used darker and cooler colors to start showing form with color. A few strokes of a warmer color were used next to the rocks for color temperature contrast. Notice how the line and mass drawing in the underpainting is strongly influencing the first colors that are being put in.

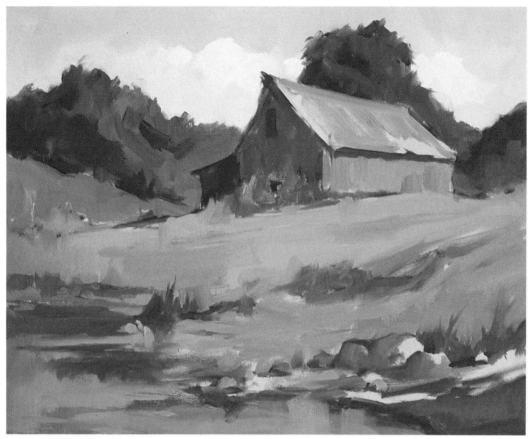

Step 5 I began to add different colors to the painting as I developed individual forms. The painting's surface becomes more fully covered as block-in colors are expanded and individual forms solidify. I used the same color pigments for the different base color areas. Only now, certain colors are strengthened or reduced as needed by the addition of another color to the original base color. Compare this stage of the painting to the original line and mass beginning and see how the first drawing influence is still present in the painting.

Detail I added a violet to the roof of the barn and let it mingle with some of the wet, cool color from the first painting stage. Olive green was brushed into the sides, and the shadows were overpainted. The shadow color is a combination of warm earth colors and similar value cool colors that I mingled while wet, being careful not to overbrush. Individual traces of each color show through. A stronger red was added to the bushes at the barn's corner. More painting was done in the red trees and blue sky behind the barn. This enhanced its appearance and gave it more depth. Controlled edges now help suggest form and surface texture.

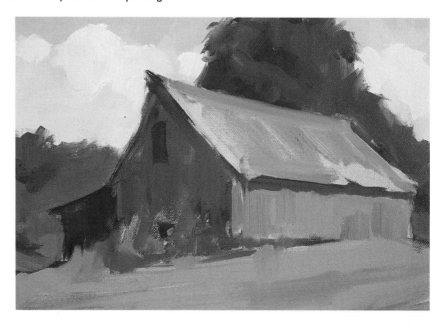

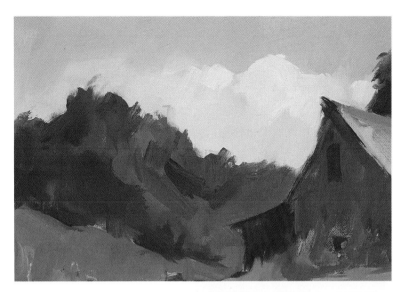

Detail The sky and trees were developed with more painting. A small amount of cobalt blue was mixed with white and brushed into the wet blue sky to start blocking in some clouds. Alizarin and white were brushed into the lower part of the sky below the clouds to give it atmosphere. Deeper darks and sharper edges helped bring out more form in the trees. The tree line against the sky was developed with more detail to identify the red mass as trees. Cobalt blue was brushed into the upper sky area to darken it.

Detail Notice how the water along the shoreline was developed. Some red was worked into the blue color of the water as a reflection. I then painted in lighter bluish colors as surface reflections, allowing the colors to mingle together in places. Darker accents with sharp edges were added to define the water's surface. Some darker forms and linear accents of grass were brushed into the grassy area behind the water. More of the original warm color was brushed over the unpainted area above and behind the rocks. At this stage of a painting, it is important to leave brushstrokes alone so that definite edges and other accents stand out where needed.

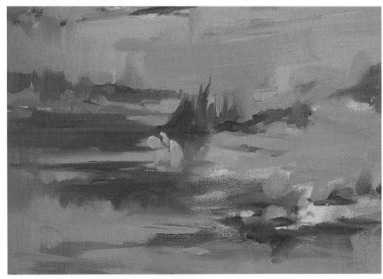

Detail I painted the rocks with violet colors and brushed in a lighter warm color behind them. This gave the area a good contrast of color temperature. Reflections were brushed into the water with lighter and darker colors. Although there are a lot of cooler violet colors in the rocks at this time, I planned to paint warmer colors back into them later. As a painting develops, it is important to think ahead. Colors can be used now to help develop different colors later. Tonal values that are put in at the beginning should remain and be used as a guide, but colors can always be changed.

The last stage of this painting shows how all the forms pulled together as I painted in the final colors. I still used my original color palette. The foreground, in both rocks and water, shows more refinement. When I painted these areas, I used lighter colors to model form in the rocks as well as the water. Some additional cooler colors and darker accents were brushed into the field. The clouds were strengthened.

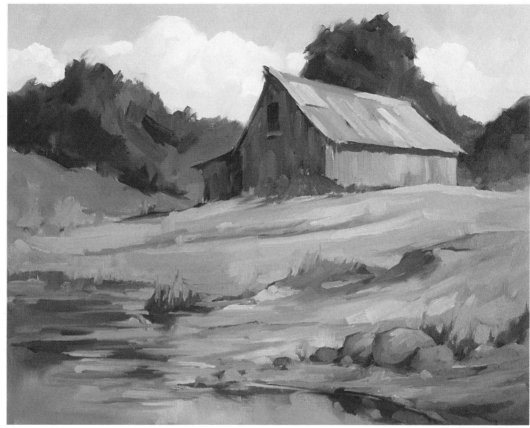

Red Trees and Barn, 1991, 16″ × 20″

Detail The roof of the barn was finished by brushing in lighter cool grays and accents of darks to suggest surface texture and form. Some warmer grays and cool accents were put into the dark shadows to give them more form and space. The red bushes at the barn's corner were finished with red accents and surface form. All of these finishing colors were developed by following the first basic block-in of colors. Always make sure that you have a good start for your painting and a clear direction of where you want it to go.

Trees and Foliage

Trees and foliage are painted with masses of dark and light to give them volume and strength. Squint at the two paintings on this page and notice the power and influence of the dark and light masses. Trees with full foliage, especially at a distance, will usually appear dark. As you get closer, some of the lighter leaves and branches separate from the darker masses to suggest the tree's surface form.

Edges are an important part of building up a tree's form. A tree's outer edge is clearly seen against the lighter sky and helps to identify it immediately. Some contrasting edges of light leaves against dark, and dark against light are brushed in with crisp strokes. Painting knives can give good accents of color. Sometimes a light branch in a tree mass can reverse its value and appear darker as it overlaps the lighter sky.

Colors in trees vary according to the type of tree and the season. The time of day and general lighting also influences the color. Try mixing your greens from different combinations of yellow and blue pigments with warmer reds added to gray the color. Any of the other families of color could be used instead of green.

Detail of **Trees**, 1984, 12″×16″

Edge of the Woods, 1990, 9″×12″

Linear Perspective

As things recede from you, they become smaller and eventually disappear altogether deep in the background. Linear perspective gives the artist a controlled way of showing these receding and diminishing forms.

The first important principle in linear perspective concerns the use of the eye-level line. This is an extension of your line or plane of vision carried horizontally and level all the way into the background. All receding forms will disappear at some point on the eye-level line. All surfaces or edges that recede in the *same* direction converge and eventually disappear at one point only.

This place of convergence is called a vanishing point. Therefore, the sides of buildings, the edge of a street, a fence or shadow will all converge toward the same vanishing point if they are receding in the same direction. If another surface recedes in a *different* direction, then another vanishing point is necessary.

If something is *above* the eye-level line, it will converge *downward* toward a vanishing point on the eye-level line. If something is *below* the eye-level line it will converge *upward* toward a vanishing point.

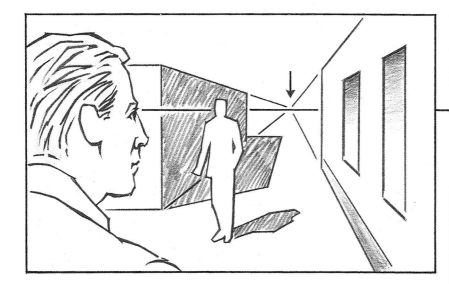

The eye-level line is an extension of your plane of vision into the background. When something recedes from you into the background, it will eventually disappear at a vanishing point located on the eye-level line.

Eye-Level Line

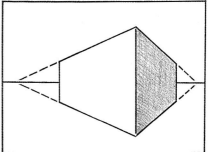

Surfaces receding into the background in different directions will each have their own vanishing point.

If you are standing, then all standing figures will have their heads on or near your eye-level line because of their similarity in height. This common eye-level line causes these figures to look correctly placed and unified. Notice that the surface on the left converges to a vanishing point outside the picture rectangle.

Since everything that recedes will converge at one vanishing point on the eye-level line, then receding shadows will also converge. This convergence at the same vanishing point helps unify a picture. Even if the vanishing point is outside of the picture rectangle, the idea is still the same.

Atmospheric Perspective

In addition to using linear perspective, an artist achieves depth in a painting with atmospheric perspective. When objects and forms in a landscape begin to recede, they not only become smaller in size but atmosphere or space begins to seperate them from the viewer. This causes a change in their values and colors.

The more distant an object is, the more atmosphere fills up the spaces between it and the viewer. This results in a diminishing of colors and value contrast. Colors in a distant part of the landscape appear weaker and less intense than colors in the foreground. Very dark tonal values become lighter as they recede into the background. Usually during the day, blue and violet influence the background colors. Atmospheric effects will be stronger on hazy days or when weather conditions, like rain, affect a view.

For more control in achieving depth in a landscape, divide the picture into a foreground, a middle ground and a background. Keep each of these separate with atmospheric perspective.

Always divide a landscape view into three distinct areas of depth: the foreground, middle ground and background. Generally, make more distant areas cooler in color than the closer areas. Keep the deepest darks up close for greater depth.

This wooded landscape scene uses atmospheric and linear perspective to achieve depth. Trees become smaller in the distance. Deeper darks are stronger in the foreground. The late afternoon light gives a particular atmospheric effect to colors. Although the background colors are light and warm, there still is a gray influence about them that creates distance. There is a clear foreground, middle ground and background.

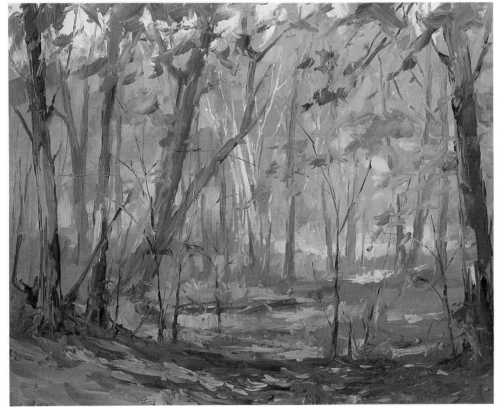

Late Afternoon Woods, 1980, 11″ × 14″

Weather and Atmosphere

Different weather effects always have a strong influence on the appearance of a scene. Weather creates atmospheric conditions that drastically change colors and tonal values in different parts of a landscape.

With rain or snow, there is a lot of diffusion or softening of forms in the background. When seen through falling rain, daytime background colors become cooler and grayer. Edges are softened and disappear altogether in places. The heavier the rainfall, the more lost and diffused the background becomes.

At certain times there is a heaviness in the air that strongly affects distant parts of a landscape. Two examples of this particular atmospheric effect of weather are shown here.

In *Rainy Night*, the background areas are totally lost in the diffusion of light. Only the stronger lights come through. The closer forms are darker and strong in color grays, but because of the rain, their edges are not sharp. Some linear strokes of lighter grays slanting downward across darker areas suggest falling rain. Background lighting is very effective in showing a strong rain effect at night.

Although there are a lot of cooler color grays, they are balanced by warmer colors as shown in the detail. Like any good painting, this night view of rain still has a balanced arrangement of dark and light tonal values.

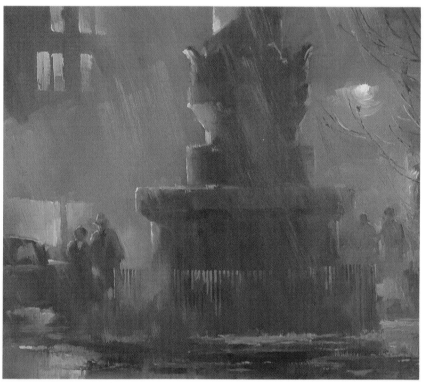

Rainy Night, 1978, 11″ × 14″

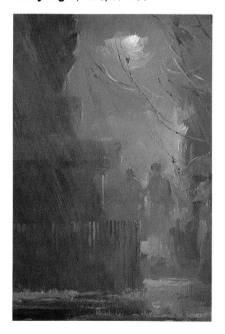

114

This painting of a forest during a winter sunset shows how a winter haze in the woods diffuses the warmer sunlight throughout the picture. Trees and other forms in the background are simplified into flat shapes with many lost edges. Backlighting diffuses forms when a heavy atmosphere spreads out the light. A similar light effect was used in the rainy night painting shown on the previous page.

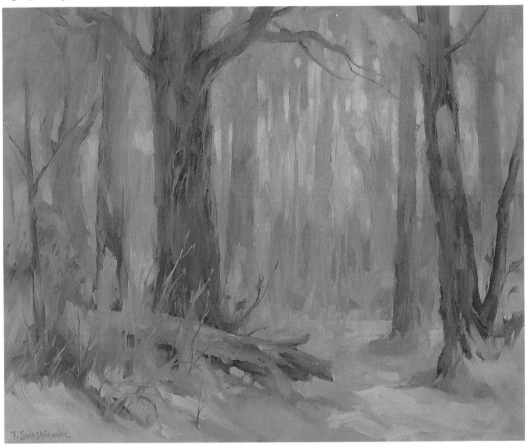

Winter Forest at Sunset, 1990, 20″ × 24″

Morning Fog demonstrates how a very dense atmosphere totally loses the background. In a fog, things rapidly diminish in strength and appearance. Forms in the middle ground become simplified into flat shapes with soft edges and lighter values. The background completely disappears. Brushing a common gray color over the entire painting surface and then painting forms directly into it while it is wet is a good beginning approach.

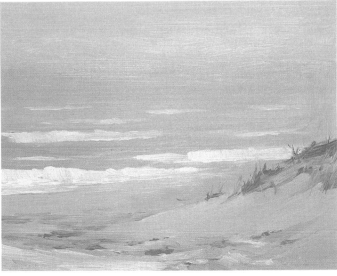

Morning Fog, 1982, 8″ × 10″

Water

Water depends on the surrounding areas, including the sky, for its color. However, its own local color is still a primary influence. Sometimes, as in the case of a shallow stream, the submerged sand and pebbles will affect the water's color.

Since water is highly reflective, it will look bluish when the sky is clear and blue. If the sky is overcast and gray, water will show that grayer influence, and the brighter blues will be missing. In *Rough Water*, cooler gray sky colors affect the water's green color.

Besides reflecting color, water absorbs light and color. Therefore, in reflections, lighter colors reflect slightly darker and darker colors reflect slightly lighter. If water is strongly colored, then the reflected colors will also be affected by that color. For instance, water that has an olive green color will color all reflections with a little of that green.

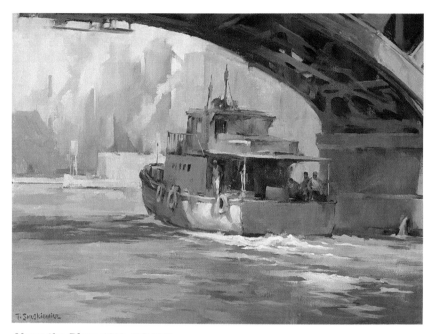

Along the River, 1989, 18″ × 24″

In this water painting there is a strong dark and light tonal arrangement that holds the picture together. The water is painted a gray-green with touches of warmer colors reflecting from the boat. The white foam in the boat's wake helps give it some movement. Atmospheric perspective diminishes the colors of the background, giving this painting its depth.

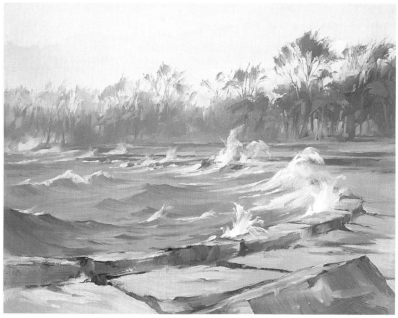

Here the cool gray sky color affects the local green color of the water.

Rough Water, 1980, 11″ × 14″

Night

At night, individual and separate forms lose themselves. Although values are more closely related at night, strong contrast can appear, as in *Winter Night*. Generally, though, there is a pulling together of everything into simple masses. Forms that we easily recognize during the day become something else at night, and our imagination takes over. Colors are in the cooler family with some warmer contrast for balance.

In moonlight, the shadows are very dark and the light areas are strongly influenced by cooler colors such as blue, blue-violet and even blue-green. Edges are not too clear and sometimes lose themselves completely. Since moonlight is much weaker than sunlight, forms emerge in a softer way. The lack of reflected light in the shadows keeps them dark and flat.

Night paintings, with all their simplicity and lack of detail, can still have a lot of power if the correct contrast of value and color is used along with the larger dark masses.

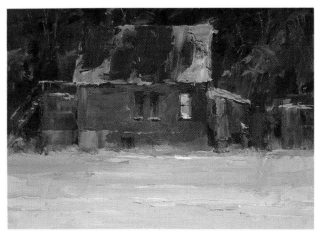

Winter Night, 1978, 9″ × 12″

Though values are usually dark at night, snow can create strong contrast, as in this painting.

Moonlight, 1991, 9″ × 12″

Simplicity of form and lack of detail are qualities of moonlight. Darker areas merge together into simple masses, and lighter areas are cool in color. Study moonlight effects by direct observation from life.

Project Painting Landscapes

For your chapter project, try painting outdoors directly from life and nature. All you need is a sketching-paint box that will hold some panels in its lid. You can work with the box held on your knees while sitting on a folding camp stool.

Select simple subjects to work from, and don't forget to squint in order to see the larger masses of dark and light and the correct values of different colors. Use a line and mass approach as demonstrated in this chapter and establish the masses of value early in the painting. Don't use too many colors on your palette; limit them to basic yellow, red and blue groups.

If you study color directly outdoors, you will learn a great deal about landscape painting. It is not the detail that makes a good landscape, but the way color is used to create an effect of light and depth.

Project: Try to find a simple subject that has good light and dark divisions and a definite color temperature. I painted this small study quickly and kept the light areas warmer and the shadows cooler. I used a line and mass approach to establish the light effect rapidly as it was late in the afternoon and the sun was about to set. Keep your eyes open for interesting places and make notes on how they look at different times of the day.

Pond at Sunset, 1980, 5″ × 7″

Trees are always good subjects to paint because a variety of form and lighting effects is available. I painted this group of trees because I was impressed with the strong backlighting. This created dark contrast against the lighter yellow-green foliage behind. Very light, sharply defined edges help to show this effect. I used a line and mass approach with brush and knife for this painting.

Project: Look for unusual lighting effects and don't have a preconceived idea of what you will paint. Keep your mind and eyes open and you will see a lot.

Trees, 1982, 11″ × 14″

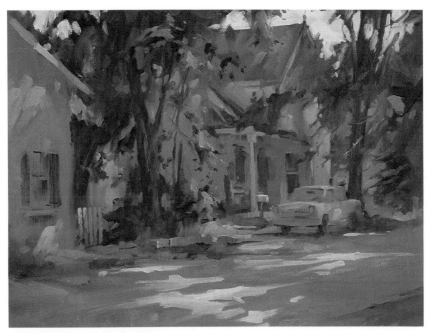

Project: Try doing a small painting on a street in your neighborhood. I found this shady street in a small town that I was passing through. I painted it in my sketching-paint box as I sat on a ledge. The pattern of sunlight and shadow impressed me, so I used a tonal approach to get the painting started. This picture has a simple, one-point linear perspective. I drew in my eye-level line right at the beginning to guide the first placement of forms. After the tonal drawing was put in by wiping out the lights, the basic colors were painted directly into it. To find interesting subjects for study, you don't have to go very far. Sometimes, you can even find an interesting landscape subject right outside your door.

Shady Street, 1990, 12″ × 16″

This small study was painted rapidly using a painting knife. Although it lacks detail, there still is a strong composition based on tonal arrangement and color. I painted it in my sketching-paint box while at the zoo. It had been raining that morning, but the sun was now beginning to come out. The colors were rich and varied because of the recent rain. All this contributed to the subject's appearance as I sat on a park bench and painted.

Project: Take your paint box to a zoo or park and sit down in some shady corner. Look around, study carefully what you see, and paint it on a small panel. Work with a knife but start the painting with a brush to get a solid line and mass beginning.

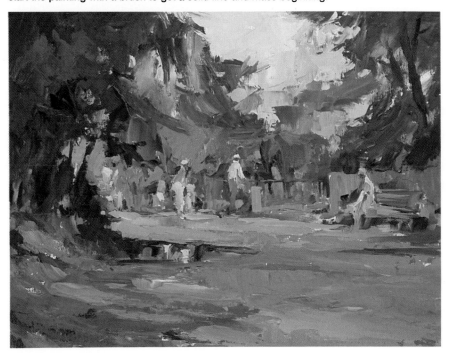

Morning at the Zoo, 1991, 9″ × 12″

Chapter Eight

Painting People

Of all the subjects to paint, people are probably the most difficult. Tonal value and color relationships are so varied between individuals and human form is so complex in construction that painting people is always a challenge. Subtle changes of value and color in the human form demand that the painter observe closely and accurately.

Although human form is complex in construction, difficult and involved parts can be simplified at the outset. Just like any other subject, the human form can be first reduced into simple and basic shapes. The easiest approach is to think of form, no matter how many curves the surface shows, as being made of flat planes with definite divisions between them. In this way, as light strikes a subject, it can be seen as a blocklike form with strong surface changes of value.

Starting a painting with large masses of dark and light helps a painter get immediately into the basic construction of human form. The line and mass approach

is a good way to begin. It allows form to be built up in a controlled way using dark and light values. The best way to learn to paint people is by working directly from life. If you put a light on your subject and arrange it so there are strong value and color changes, it will be easier to see form. Seeing something clearly first makes it easier to paint.

You don't need an elaborate setup to paint people from life. One of the most important elements is lighting. Make sure that you use only one main light source. That way it will be easier to see surface form and how it changes in value and color. Your light source could be a table lamp, a floor lamp or a clamp-on reflector-type lamp. Daylight is also a good source if you can control its direction. Have your subjects sit by a window, then adjust the blinds or drapes so that a good light brings out their form. When working from daylight, it may be difficult sometimes to see subtle changes of form. Squinting will help you see them.

A strong light coming from one direction creates an arrangement of dark and light values within the picture's borders.

Some colors are close in value but not in color. Here, the red tie and suspenders are similar in value to the shirt's gray shadow.

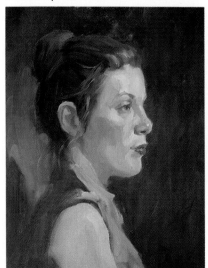

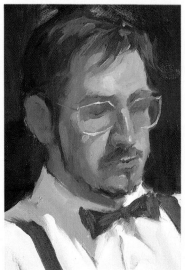

Girl in Blue, 1987, 14″ × 18″

Detail of *Chris*, 1989, 16″ × 20″

The Effect of Light on Human Form

Light coming from one main direction enables us to see and recognize human form. There are many different surfaces on a human subject that change the form either gradually or more abruptly. As light strikes these different surfaces, some of them remain fully in light and some go into shadow. This creates an arrangement of dark and light values. Surface forms are seen and identified because different dark shapes and edges become visible. In light coming from a definite direction, each part of the human form has its own distinct value shape and edge. As the light changes, there will also be a corresponding change in value shapes and edges.

Edges are an important way of identifying human form. Some edges are sharply defined and show abrupt changes in a form's surface. Other edges are softer and show gradual changes such as those that occur on a curved surface. As an edge between a dark and light area softens, a middle value is created. Middle values connect the darker and lighter values and give continuity to the whole value range. They help show the full effect of form by depicting how a surface changes. Depending on the surface form itself, they can be large or small in area.

Cast shadows have well-defined edges. On facial features, cast shadows merge with other darks to help identify form.

Light coming from one direction shows surface form by the light and shadow areas it creates. If the light direction changes, the amount of light that a surface receives will also change. Some areas become darker while others become lighter. A significantly changed light direction will completely change the appearance of human form.

Detail of ***Barb***, 1989, 16″ × 20″

Flesh colors appear warm and rich under a warm light; shadow areas look cool and gray. Always keep in mind the color or temperature of light when mixing flesh colors.

Portrait Demonstration

In this portrait demonstration of my photographer friend Naldo, I used a line and mass approach to get started. I had Naldo sit holding his camera, but I didn't force any pose on him. I just told him to think about photographing something. Never force someone into a pose; it will never look natural. Instead, let your subjects relax and find the pose themselves, using your suggestions of what they are supposed to be doing as a guide.

I worked on a 20 × 24-inch stretched canvas with a white ground. I began to sketch in the first big lines that enclosed the figure with a thinned mixture of terra rosa and viridian. This gave me the important basic proportions and their placement. Next I indicated where his head, neck, shoulders and arms were and then started to put in the darker masses. I avoided showing detail but tried to be accurate in drawing these dark shapes by using correct edges. A little tone was worked in around his head and on his shirt for contrast. Some incorrect edges were wiped out and the correct ones put in. At this beginning stage of the painting, it is important not to get involved with too much detail. Put all your efforts into establishing a good drawing that shows basic proportions and the major masses of tone.

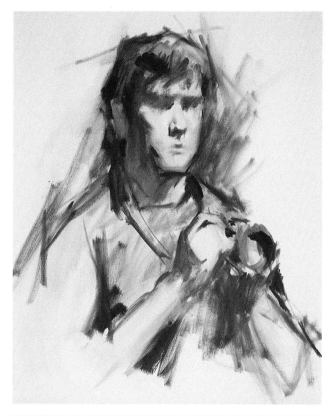

Step 1 Using viridian and terra rosa without any white, I sketched in some of the major dark tonal areas without getting involved with detail. I blocked in the hands according to their basic planes or surfaces. At this stage, line and tone serve as a foundation on which to build the basic colors.

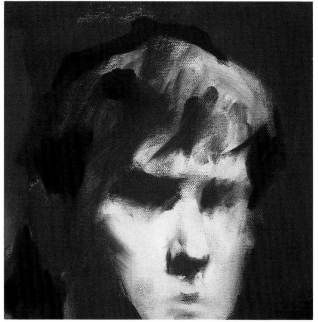

Step 2 I blocked in this first tonal drawing of the facial features with simple dark shapes. The edges of these dark masses have to be accurate to show the underlying form. A solid background color was put in with some thought given to its final appearance in the painting.

Step 3 I started to block in some of the basic colors. Using families of color as a guide, I first found the correct hue and tonal value such as a dark yellow-green for the background. Next the color's intensity and grayness were determined by adding other colors. Before getting into the lighter areas, make sure the darks and middle-value colors are put in for contrast.

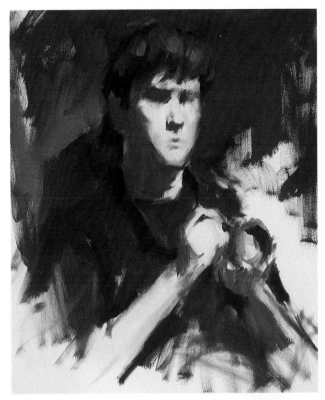

Step 4 I added color to the head, keeping in mind the surface form and basic proportions of the drawing. I continued to avoid detail in the facial features but started modeling in the major planes of the face using warmer and cooler colors. Terra rosa, cadmium yellow light and a little alizarin were the basic pigment colors used for the flesh colors. White was added to lighten values, and viridian or cobalt blue was used to cool and gray colors.

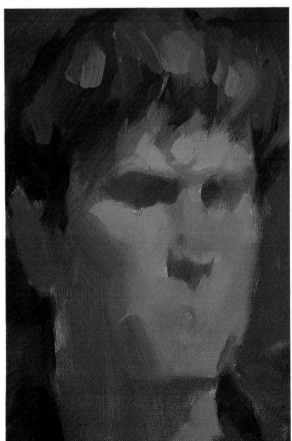

Step 5 I blocked in the color of the hands using warmer and cooler colors. Darker values began to bring out the basic surface planes of the form. The dark shirt served as a good contrast for the lighter flesh colors.

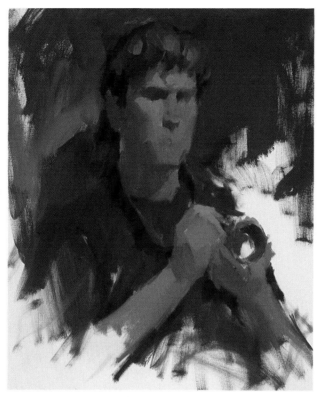

Stage I As the block-in colors filled up the picture, a solid feeling of form and a sense of light started to appear. There is still a lack of detail but much of the basic form is indicated.

Detail Refinement in the facial features is starting to take place. The eye socket was shaped more solidly by correcting edges. The nose and mouth have begun to emerge now because of more subtle modeling with value and color. Highlights helped to complete some of the facial forms. A few more lights and darks brought out the hair.

Always model form according to the main light illuminating the subject.

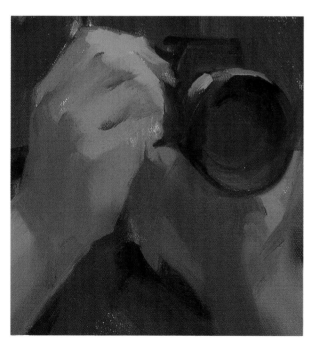

Detail Always build modeling and detail in the hands after you have a good indication of basic surface planes. More refinement with value and color was also put into the camera by observing its basic shape.

In this final stage of the painting I finished the background with some warmer colors. I painted the background against the figure's form to correct its outer edge where necessary. Finished form was brought out in the facial features as well as the hands by refining colors and edges. All this begins to pull the painting together and gives it a finished appearance.

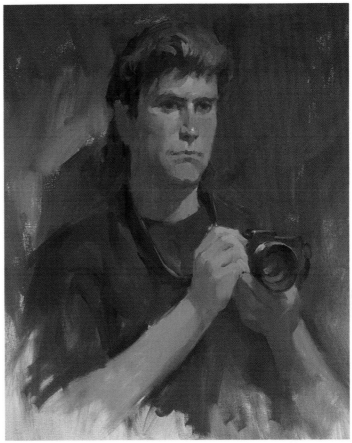

Naldo, 1991, 20″ × 24″

Detail The fingers were finished in both hands by controlled modeling with value, color and edges. The original block-in of the basic surface planes was a foundation for this detail.

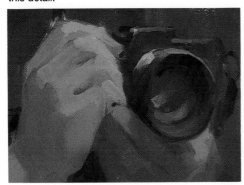

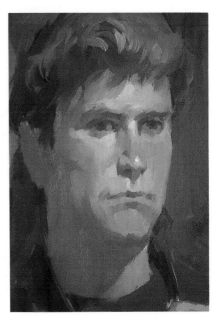

Detail I painted the eyes directly into the dark shapes of the eye sockets using the correct dark and light accents and edges. A little more modeling was done in the face and head using subtle value and color temperature changes. All contour or outer edges were corrected by painting into the background or by painting the background into the figure's form. A few sharp accents were put into the hair for interest and form.

Building Form With Paint

When painting with oil paint, apply the paint as if you were modeling with every brushstroke. Let each stroke mean something and add to the painting's effect. Only oil paint has the feel and working qualities that combine good color with different kinds of surface effects.

Model form with paint by first beginning with good tonal value control. Only the strength of darks and lights can construct the full shape and depth of form. Good color is first built on a solid tonal value foundation. As color changes begin to show form, tonal value changes are also helping.

The way that oil paint is applied can add a lot to the effect of light and form. When making brushstrokes, think of the way the surface is going and paint in color to suggest the surface itself. Don't always brush your colors in the same direction but let the form guide your brushstrokes.

By applying your colors with the right kind of brushstrokes, form can be suggested that has more than just color. It can have depth and dimension, too.

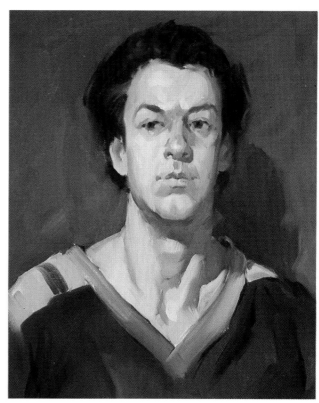

All form is first painted with good dark and light value construction. This tonal painting shows the power of only value in showing form and a sense of light.

The facial features shown in this detail were painted with deliberate brushstrokes. Different directions in each stroke helped model surface form along with good color and value control. Look at the way form in the eye and nose emerges with several well-placed brushstrokes. Always think of how brushstrokes can be used to build a certain form.

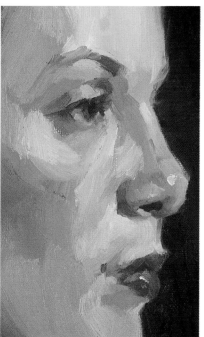

To block in this hand, I used dark and light tonal value construction, color temperature control, and direct brushstrokes. The highlights on the wrist were brushed in strongly compared with other longer and softer strokes that shape the hand. You can see how brushstrokes were left alone as they were laid over or next to each other. The deep crimson color helped shape the outer edge of the hand by being brushed directly against it.

Detail of *Girl in Blue*, 1987, 14" × 18"

Before finishing colors are added to develop form, lay in some solid masses of color that describe the basic shapes. In this hard hat detail, darker yellow colors were used for the first basic shape. Brushstrokes were laid in boldly. Outer edges were found by painting the background color directly against the hard hat's yellow color. The final brushstrokes put in highlights and other strong accent edges.

This detail shows the use of good values and colors. Edges and brushstrokes were deliberate and well placed to model facial forms. Notice how brushstroke directions add to the effect of surface change on the face. Pay attention to edges. Without good edge control, it is difficult to model form. Color temperature control is also important as it can help show subtle surface changes.

The form of this jacket sleeve is brought out by a combination of directional brushstrokes and solid dark and light construction. The red scarf is first painted with dark and light values to show its form. The light design is then worked into it, guided by value changes in the surface. When building form with paint, try to control brushstrokes so they follow the surface and work effectively with tonal values and edges.

Detail of **Man in Hard Hat**, 1989, 16″ × 20″

Detail of **His Red Scarf**, 1990, 20″ × 24″

This painting shows the power of brushstrokes when combined with good tonal value construction. I started this painting with a line and mass approach and found form first with values. Base colors were painted in for all major areas. Much attention was devoted to correct edges. Look at the variety of edges and how they work together with tonal values and colors.

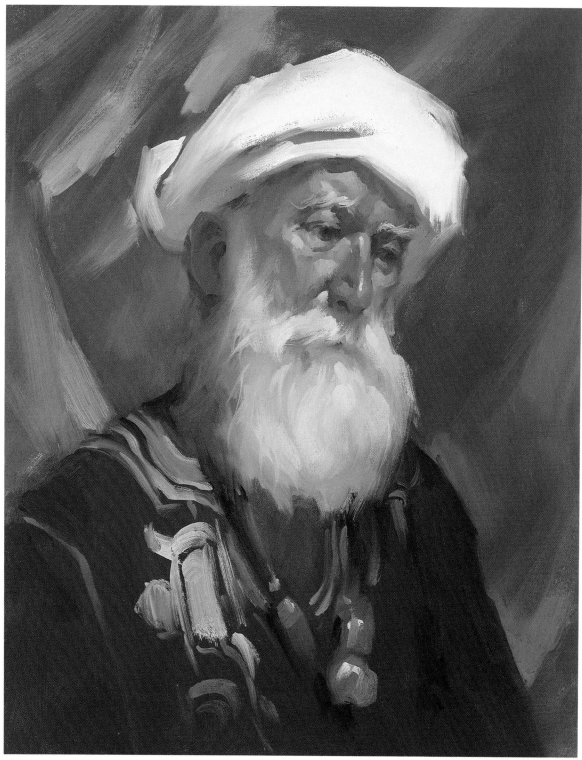

Man in the White Turban, 1991, 16″ × 20″

I painted this young girl in a very short time. I used a tonal approach to get started and wiped out light areas to achieve a dark and light tonal value foundation. Colors were brushed in boldly, always guided by that first tonal drawing. Several good base colors blocked in the whole painting and established a color harmony. The first effect of light on form developed as I began to control values and edges. Individual brushstrokes were left alone as more color was added. Although this picture was painted rapidly, it has a good light effect that shows all the basic forms of this subject.

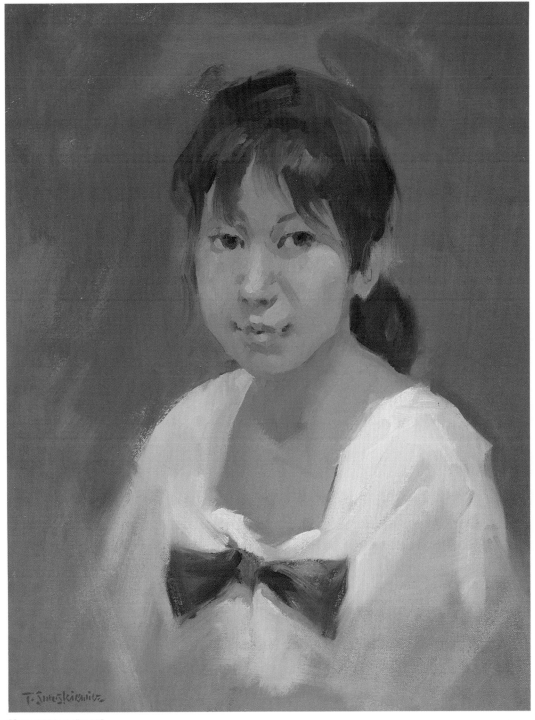

Una, 1990, 14″ × 18″

Project Painting People

You can learn the most about painting people by painting someone directly from life. It is only through direct study from life that you learn to see how light affects surface form. The ability to use color to correctly build form comes with constant practice.

The best way to begin to paint people is to start with the basics. Get someone to pose for you. Have him or her sit or stand under a good light as described earlier. For the chapter project, paint a series of studies from life using different approaches. Start off with just basic tonal drawings. Then, using a dark gray color with white, paint some tonal painting studies. Next, select a warm and cool color and do color temperature paintings. After practice with some basic painting techniques, start working with full color, but don't forget what you were doing with the tonal value and color temperature studies. Remember, they are the basis for controlled color use and should be practiced often.

Project: Do a tonal drawing as above and then mix up five values by adding white to lighten values. Start brushing in the correct values of paint, matching them against the tonal drawing. At the beginning, only block in the important basic values. Later, refine edges so form begins to emerge.

Project: Using a warm gray color and only paint thinner, paint a tonal drawing from life. Start with a toned canvas or panel. Paint in some of the basic lines and dark shapes, wipe out the lights, and refine edges by rubbing or brushing them back in. Draw with tonal shapes and edges. Don't use any white. To lighten a darker value, just rub it with a rag.

Project: Now paint a two-color value and temperature study. Select a warm and cool color, like terra rosa and ultramarine blue for instance, and block in your painting as practiced in the tonal painting study. Squint to see value and color relationships.

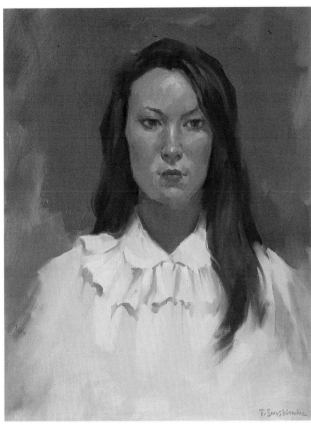

Colleen, 1989, 16″×20″

Project: Have someone pose wearing something interesting but simple. Work on a good block-in of the clothing, starting with darks and lights and maintaining good edge control. Use a closely related color harmony in the painting.

Try another pose using full color. Work under a different light, perhaps daylight coming from a window. Keep your brushwork somewhat loose and simple. However, try to get a good effect of light by using good tonal values and color.

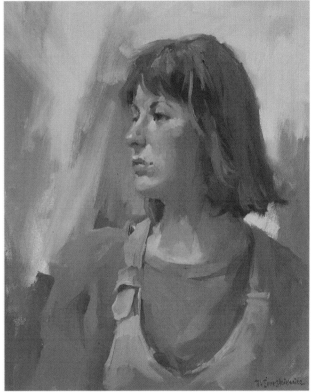

Pam, 1990, 16″×20″

Summer Fun, 1978, 9″×12″

Project: Try working up a painting from imagination with figures in it. Pick a subject and work out a composition in dark and light values as discussed earlier. Don't just copy a photograph. Use only two colors and concentrate on a good effect of light with color temperature. For this painting, I used burnt sienna and ivory black. Try not to be too detailed; go for action and feeling with your figures. Use a brush or painting knife and try something different in your strokes.

Conclusion

Learning to paint is more than just accumulating technical skills and putting paint on a canvas. The ability to do something new with those acquired skills is what makes you an artist. It is not so much the level of technical achievement but the level of originality and creativity in the way those skills are used that matters.

In this book, I have taken you from the first steps in learning to use basic oil painting equipment and material to learning how to paint something as you see and feel it. We have explored the power of tonal values and how to put them together for maximum effect. The enchantment and force made possible by color was covered in depth. The chapter on putting it all together and my demonstrations on using oil paint have shown you how to get the most out of your painting. I have guided you through the whole painting process. Now it is up to you.

As you have been reading my book, you have also been painting. If you have followed my instructions and carefully applied what I have shown, there should be something new beginning to appear in your work. It may not be much at first, but if it is there, it will begin to grow with practice and perseverance. Work at it as much as you can and nurture these first results until they develop into a consistent strong foundation in your painting.

Don't be afraid to make mistakes. It is only through recognizing our errors that we learn what is right. Learning comes from trying to correct what is being done wrong. If you feel that your painting is not working, tear it apart by concentrating separately on such basics as tone, color and technique. Ask yourself questions about your painting, but don't always accept your first answer; think it out a little.

Imagination is the key that unlocks your painting. It could open the door to another world, a beautiful place full of anything you are looking for in your painting. Encourage that imagination and use it. What better way is there to use your imagination than to paint directly from life. When you paint something from life, don't just copy it. Paint what you see in that subject.

You are an individual, there is only one of you, so don't paint like everyone else. Trust yourself. Believe in what you see and paint it that way. Let the technical skills you acquire guide your hand but also have the courage to listen to your heart.

Index

Improve your skills, learn a new technique, with these additional books from North Light

Graphics/Business of Art

Airbrushing the Human Form, by Andy Charlesworth $9.95 (cloth)

Artist's Friendly Legal Guide, by Floyd Conner, Peter Karlan, Jean Perwin & David M. Spatt $18.95 (paper)

Artist's Market: Where & How to Sell Your Graphic Art, (Annual Directory) $21.95 (cloth)

Basic Desktop Design & Layout, by Collier & Cotton $27.95 (cloth)

Basic Graphic Design & Paste-Up, by Jack Warren $14.95 (paper)

Business & Legal Forms for Graphic Designers, by Tad Crawford $15.95 (paper)

Business and Legal Forms for Illustrators, by Tad Crawford $15.95 (paper)

CLICK: The Brightest in Computer-Generated Design and Illustration, $39.95 (cloth)

COLORWORKS: The Designer's Ultimate Guide to Working with Color, by Dale Russell (5 in series) $24.95 ea.

Color Harmony: A Guide to Creative Color Combinations, by Hideaki Chijiiwa $15.95 (paper)

Complete Airbrush & Photoretouching Manual, by Peter Owen & John Sutcliffe $24.95 (cloth)

The Complete Book of Caricature, by Bob Staake $18.95

The Complete Guide to Greeting Card Design & Illustration, by Eva Szela $27.95 (cloth)

Creating Dynamic Roughs, by Alan Swann $12.95 (cloth)

Creative Director's Sourcebook, by Nick Souter & Stuart Newman $34.95 (cloth)

Design Rendering Techniques, by Dick Powell $29.95 (cloth)

Desktop Publisher's Easy Type Guide, by Don Dewsnap $19.95 (paper)

The Designer's Commonsense Business Book, by Barbara Ganim $22.95 (paper)

Designing with Color, by Roy Osborne $26.95 (cloth)

Dynamic Airbrush, by David Miller & James Effler $29.95 (cloth)

59 More Studio Secrets, by Susan Davis $12.95 (cloth)

47 Printing Headaches (and How to Avoid Them), by Linda S. Sanders $24.95 (paper)

Getting It Printed, by Beach, Shepro & Russon $29.50 (paper)

Getting Started as a Freelance Illustrator or Designer, by Michael Fleischman $16.95 (paper)

Getting Started in Computer Graphics, by Gary Olsen $27.95 (paper)

Getting the Max from Your Graphics Computer, by Lisa Walker & Steve Blount $27.95 (paper)

The Graphic Artist's Guide to Marketing & Self Promotion, by Sally Prince Davis $19.95 (paper)

The Graphic Designer's Basic Guide to the Macintosh, by Meyerowitz and Sanchez $19.95 (paper)

Graphic Design: New York, by D.K. Holland, Steve Heller & Michael Beirut $49.95 (cloth)

Graphic Idea Notebook, by Jan V. White $19.95 (paper)

Guild 7: The Architects Source, $24.95 (cloth)

Handbook of Pricing & Ethical Guidelines, 7th edition, by The Graphic Artist's Guild $22.95 (paper)

HOT AIR: An Explosive Collection of Top Airbursh Illustration $39.95 (cloth)

How'd They Design & Print That?, $26.95 (cloth)

How to Check and Correct Color Proofs, by David Bann $27.95 (cloth)

How to Design Trademarks & Logos, by Murphy & Rowe $19.95 (paper)

How to Draw & Sell Comic Strips, by Alan McKenzie $19.95 (cloth)

How to Find and Work with an Illustrator, by Martin Colyer $8.95 (cloth)

How to Get Great Type Out of Your Computer, by James Felici $22.95 (paper)

How to Make Your Design Business Profitable, by Joyce Stewart $21.95 (paper)

How to Understand & Use Design & Layout, by Alan Swann $21.95 (paper)

How to Understand & Use Grids, by Alan Swann $12.95

International Logotypes 2, edited by Yasaburo Kuwayama $24.95 (paper)

Label Design 2, by Walker and Blount $49.95 (cloth)

Labels & Tags Collection, $34.95 (paper)

Legal Guide for the Visual Artist, Revised Edition by Tad Crawford $8.95 (paper)

Letterhead & Logo Designs: Creating the Corporate Image, $49.95 (cloth)

Licensing Art & Design, by Caryn Leland $12.95 (paper)

Make It Legal, by Lee Wilson $18.95 (paper)

Making a Good Layout, by Lori Siebert & Lisa Ballard $24.95 (cloth)

Making Your Computer a Design & Business Partner, by Walker and Blount $27.95 (paper)

Marker Rendering Techniques, by Dick Powell & Patricia Monahan $32.95 (cloth)

New & Notable Product Design, by Christie Thomas & the editors of *International Design* Magazine $49.95 (cloth)

Papers for Printing, by Mark Beach & Ken Russon $39.50 (paper)

Presentation Techniques for the Graphic Artist, by Jenny Mulherin $9.95 (cloth)

Primo Angeli: Designs for Marketing, $19.95 (paper)

Print's Best Corporate Publications $34.95 (cloth)

Print's Best Letterheads & Business Cards, $34.95 (cloth)

Print's Best Logos & Symbols 2, $34.95 (cloth)

The Best of Neon, Edited by Vilma Barr $59.95 (cloth)

The Professional Designer's Guide to Marketing Your Work, by Mary Yeung $29.95

3-D Illustration Awards Annual II, $59.95 (cloth)

Type & Color: A Handbook of Creative Combinations, by Cook and Fleury $39.95 (cloth)

Type: Design, Color, Character & Use, by Michael Beaumont $19.95 (paper)

Type in Place, by Richard Emery $34.95 (cloth)

Type Recipes, by Gregory Wolfe $19.95 (paper)

Typewise, written & designed by Kit Hinrichs with Delphine Hirasuna $39.95

The Ultimate Portfolio, by Martha Metzdorf $32.95

Art & Activity Books For Kids

Draw!, by Kim Solga $11.95

Paint!, by Kim Solga $11.95

Make Clothes Fun!, by Kim Solga $11.95

Make Prints!, by Kim Solga $11.95

Make Gifts!, by Kim Solga $11.95

Make Sculptures!, by Kim Solga $11.95

Watercolor

Basic Watercolor Techniques, edited by Greg Albert & Rachel Wolf $14.95 (paper)

Buildings in Watercolor, by Richard S. Taylor $24.95 (paper)

The Complete Watercolor Book, by Wendon Blake $29.95 (cloth)

Fill Your Watercolors with Light and Color, by Roland Roycraft $28.95 (cloth)

Flower Painting, by Paul Riley $27.95 (cloth)

How To Make Watercolor Work for You, by Frank Nofer $27.95 (cloth)

Jan Kunz Watercolor Techniques Workbook 1: Painting the Still Life, by Jan Kunz $12.95 (paper)

Jan Kunz Watercolor Techniques Workbook 2: Painting Children's Portraits, by Jan Kunz $12.95 (paper)

The New Spirit of Watercolor, by Mike Ward $21.95 (paper)

Painting Nature's Details in Watercolor, by Cathy Johnson $21.95 (paper)

Painting Watercolor Portraits That Glow, by Jan Kunz $27.95 (cloth)

Splash I, edited by Greg Albert & Rachel Wolf $29.95

Starting with Watercolor, by Rowland Hilder $12.50 (cloth)

Tony Couch Watercolor Techniques, by Tony Couch $14.95 (paper)

Watercolor Impressionists, edited by Ron Ranson $45.00 (cloth)

Watercolor Painter's Solution Book, by Angela Gair $19.95 (paper)

Watercolor Painter's Pocket Palette, edited by Moira Clinch $15.95 (cloth)

Watercolor: Painting Smart, by Al Stine $27.95 (cloth)

Watercolor Workbook: Zoltan Szabo Paints Landscapes, by Zoltan Szabo $13.95 (paper)

Watercolor Workbook: Zoltan Szabo Paints Nature, by Zoltan Szabo $13.95 (paper)

Watercolor Workbook, by Bud Biggs & Lois Marshall $21.95 (paper)

Watercolor: You Can Do It!, by Tony Couch $27.95 (cloth)

Webb on Watercolor, by Frank Webb $29.95 (cloth)

The Wilcox Guide to the Best Watercolor Paints, by Michael Wilcox $24.95 (paper)

Mixed Media

The Artist's Complete Health & Safety Guide, by Monona Rossol $16.95 (paper)

The Artist's Guide to Using Color, by Wendon Blake $27.95 (cloth)

Basic Drawing Techniques, edited by Greg Albert & Rachel Wolf $14.95 (paper)

Blue and Yellow Don't Make Green, by Michael Wilcox $24.95 (cloth)

Bodyworks: A Visual Guide to Drawing the Figure, by Marbury Hill Brown $24.95 (cloth)

Business & Legal Forms for Fine Artists, by Tad Crawford $4.95 (paper)

Capturing Light & Color with Pastel, by Doug Dawson $27.95 (cloth)

Colored Pencil Drawing Techniques, by Iain Hutton-Jamieson $24.95 (cloth)

The Complete Acrylic Painting Book, by Wendon Blake $29.95 (cloth)

The Complete Book of Silk Painting, by Diane Tuckman & Jan Janas $24.95 (cloth)

The Complete Colored Pencil Book, by Bernard Poulin $27.95 (cloth)

The Complete Guide to Screenprinting, by Brad Faine $24.95 (cloth)

The Creative Artist, by Nita Leland $27.95 (cloth)

Creative Basketmaking, by Lois Walpole $12.95 (cloth)

Creative Painting with Pastel, by Carole Katchen $27.95 (cloth)

Decorative Painting for Children's Rooms, by Rosie Fisher $10.50 (cloth)

The Dough Book, by Toni Bergli Joner $15.95 (cloth)

Drawing & Painting Animals, by Cecile Curtis $26.95 (cloth)

Exploring Color, by Nita Leland $24.95 (paper)

Festive Folding, by Paul Jackson $17.95 (cloth)

Fine Artist's Guide to Showing & Selling Your Work, by Sally Price Davis $17.95 (paper)

Getting Started in Drawing, by Wendon Blake $24.95

The Half Hour Painter, by Alwyn Crawshaw $19.95 (paper)

Handtinting Photographs, by Martin and Colbeck $28.95 (cloth)

How to Paint Living Portraits, by Roberta Carter Clark $27.95 (cloth)

How to Succeed As An Artist In Your Hometown, by Stewart P. Biehl $24.95 (paper)

Introduction to Batik, by Griffin & Holmes $9.95 (paper)

Keys to Drawing, by Bert Dodson $21.95 (paper)

Master Strokes, by Jennifer Bennell $27.95 (cloth)

The North Light Illustrated Book of Painting Techniques, by Elizabeth Tate $27.95 (cloth)

Oil Painting: Develop Your Natural Ability, by Charles Sovek $27.95

Painting Floral Still Lifes, by Joyce Pike $19.95 (paper)

Painting Flowers with Joyce Pike, by Joyce Pike $27.95 (cloth)

Painting Landscapes in Oils, by Mary Anna Goetz $27.95 (cloth)

Painting More Than the Eye Can See, by Robert Wade $29.95 (cloth)

Painting Seascapes in Sharp Focus, by Lin Seslar $22.95 (paper)

Painting the Beauty of Flowers with Oils, by Pat Moran $27.95 (cloth)

Pastel Painting Techniques, by Guy Roddon $19.95 (paper)

The Pencil, by Paul Calle $19.95 (paper)

Perspective Without Pain, by Phil Metzger $19.95 (paper)

Putting People in Your Paintings, by J. Everett Draper $19.95 (paper)

Realistic Figure Drawing, by Joseph Sheppard $19.95 (paper)

Tonal Values: How to See Them, How to Paint Them, by Angela Gair $19.95 (paper)

To order directly from the publisher, include $3.00 postage and handling for one book, $1.00 for each additional book. Allow 30 days for delivery.

North Light Books
1507 Dana Avenue, Cincinnati, Ohio 45207
Credit card orders call TOLL-FREE
1-800-289-0963
Prices subject to change without notice.